Andre Norton

a Primary and Secondary Bibliography

Revised Edition

ROGER C. SCHLOBIN
IRENE R. HARRISON

Irene Harrison
dedicates this book to

Andre Norton

and

Roger C. Schlobin
dedicates this book to his sister

Susan G. S. McGee

Andre Norton

a Primary and Secondary Bibliography

Revised Edition

Roger C. Schlobin

and

Irene R. Harrison

NESFA Press
Post Office Box 809
Framingham, Massachusetts
01701-0203

Library of Congress Cataloging-in-Publication Data

Harrison, Irene R., and Schlobin, Roger C.
 Andre Norton: a primary and secondary bibliography.

Library of Congress Catalog Card Number 94-69292

ISBN 0-915368-64-1

Cover photo taken by John L. Coker III of an oil painting by Barbara Tiffany-Eginton.

This edition is an update and revision of *Andre Norton: A Primary and Secondary Bibliography,* edited by Roger C. Schlobin, Boston: G. K. Hall, 1980, 0-8161-8044-X, 79-18477.

Contents

This bibliography of works in English by and about Andre Norton is complete through November 1994. Unless otherwise indicated, all items have been examined by the compiler. The bibliographical section is divided into four chronologically arranged parts. Part A, Fiction, cites the first editions of all the novels, collections, edited anthologies, and short stories. These entries include title and textual variations, abridgments, and pseudonyms. In addition, the short story entries include all appearances. Part B, Miscellaneous Media, lists all the occurrences of Ms. Norton's poetry, and Part C, her non-fiction. Part D, Critical Studies, contains all the discussions of Ms. Norton's life and works as well as substantive reviews. These studies are fully annotated. All the citations in the bibliographic sections include full publication information and, as appropriate, notations that a work has appeared as a paperback or in an amateur publication, a "fanzine." All of Ms. Norton's works are listed alphabetically by title in the Index; critical studies are indexed by author. An introduction has been provided which surveys Ms. Norton's life, career, and major themes, and the volume concludes with two appendixes. Appendix I lists Ms. Norton's works by genre or literary type. Appendix II identifies the series interrelationships of the fiction by both plot and character.

Preface

Andre Norton

I suppose there is no one living who at one time or another has not enjoyed "talking shop" about one's particular field of labor in this world. Writers are perhaps among the professions most eager to do this. Only—the writer approaches the subject in a different way than the outsider may do. We are far more aware of the disappointments, frustrations, and lacks in our work and ourselves which tend to make us stand off and view the results with a very critical eye.

Having spent the larger part of my life now putting words on paper I find it very difficult indeed to see far beyond the fact that what DOES appear in print so often is not the bright and shining idea which teased one to get started in the first place.

It has never been my intention to do more than tell a story, for it is my firm belief that that is the one and ONLY reason for writing fiction. But the characters must be as real to the reader as they are to the writer who takes a small portion of their lives to reveal in detail. As a writer I am not as aware of words as I am of pictures—for as I write I am describing the pictures in my mind, and the people who appear therein. My characters take over in every book and I merely report their actions—a great many times they surprise me with actions I had not foreseen at all.

It has been an astounding thing for me that I have received most of the major awards in my field—the last being that of First Fandom—and I am very grateful to those who have seen fit to grant my work such standing. To be a Grand Master in any field is a proud title and I cherish this, but I know that all such recognition is not for me as a person but because of the interest and pleasure my work has given readers whom I do not know and have very little chance of ever meeting. If one can provide even an hour of escape for someone who is worried, frustrated, unhappy—then that is an award indeed and that is what I have aimed to do.

The new project of High Hallack is one which will make worthwhile many struggles and some disappointments of the past. We are working hard to establish an outstanding library of genre research and reference material—it now is well over ten thousand books and we are adding to it monthly—as well as videos and other unusual materials including fantasy art. We want this to become a center for those who not only are writing the books for tomorrow's readers but also are doing research on the outstanding materials in print in the past, providing them with peace and quiet in which to work.

I know myself what importance handy research material is for the working writer. Piles of books have given me outstanding notes, as well as plot ideas, not only for my own works such as the recent *Brother to Shadows*, *The Hands of Lyr*, *Moon of Destiny* (to be published in 1995), and *Lair of the Loden*—but also volumes from my over burdened shelves have served in the collaborations of such volumes as *Imperial Lady*, *Empire of the Eagle*, *The Elvenbane* and *Elvenblood*, and the work in progress being shared with Marion Zimmer Bradley and Mercedes Lackey—*Tiger Burning Bright*.

There is a long task before me in the near future—the ending of the Witch World Saga—the writing of *The Warding of Witch World*. So detailed is the necessary research for this that I have had to ask for the aid of Juanita Coulson to read and list all the incidents in the already published series of books.

Now I wish to give my deepest thanks to Irene Harrison, whose meticulous bibliography has at times astounded me with titles of lesser works and articles I had forgotten. Not only has she undertaken bringing Dr. Schlobin's bibliography up to date, but she is lending much time and effort to the matter of High Hallack also.

And my gratitude also to all those who have read my books, enjoyed them, and passed them along to others. Your interest has kept me going through some difficult times in the past and is a pleasure to me now.

Florida, September 18, 1994

Introduction to the Revised Edition

Irene R. Harrison

This is the diamond anniversary year of Andre Norton's writings in print. It was 60 years ago that *The Prince Commands* (A01) was published. In these 60 years Andre Norton's popularity has not declined. Both adults and children are still discovering Andre Norton books, and each of her books is a discovery in itself.

Recently Andre Norton has received more recognition for her work. In 1987 she was awarded the Howard at The World Fantasy Convention, in 1989 she was Guest of Honor at the World Science Fiction Convention in Boston, and in September of this year, 1994, she was inducted into the First Fandom Hall of Fame at the World Science Fiction Convention in Winnipeg.

In all of Andre Norton's books, people are people, no matter if they wear skin, fur, scales, or feathers. Intelligence talks to intelligence and no creature is less for looking or thinking differently. Andre's theme is that creatures, especially cats, talk to us, and we simply have not the capacity to understand.

I have read the books listed here because I enjoy what Andre has written. I collect Andre Norton books because the only way to read some of her early books was to find first editions. Much later, I discovered the Library of Congress collection, but I was already hooked.

Last spring, Andre asked me to do some fund raising for the High Hallack Project. High Hallack will be a writers' retreat in Tennessee. It will be a haven and a library for writers in all genres. This book is part of my effort for this cause.

Many people have written Andre Norton checklists and bibliographies. The 1980 edition of this book was the best of these. I used this book in my hunt for more things written by Andre Norton. Rather than start a new bibliography from scratch, I decided to begin with the best and update and revise it.

In revising this book, I have relied heavily on Roger Schlobin's 1980 work (D85) for section C. I have almost completely relied on Roger for section D (D85 & D105). I have added items to sections A and C from my own collection. I did the transcribing of the 1980 edition and the worst of the revision work. Roger Schlobin did the proofreading and correcting.

In the fourteen years since the first edition of this book, Andre has written over seventy new items of fiction, and twenty new non-fiction items. In fourteen more years I expect there to be another ninety new items to include. It will then be Roger's turn to do the grunt work and mine to just proofread.

I'd like to thank all of those people who helped make this book possible: Roger Schlobin for all of his assistance, George Flynn for his editing, John L. Coker III for his editing and cover photo, and all of the people at NESFA and the NESFA Press editorial board.

I'm doing this for Andre.

Connecticut, 1994

Introduction to the First Edition

Roger C. Schlobin

Andre Norton is one of the best known authors of contemporary science fiction and fantasy. A number of her works in the Ace paperback editions have sold over one-million copies (*Locus*, December 1977, pp. 1, 2), and many of her novels regularly remain in print for long periods of time. *Scarface* (A08) has sold over thirty-thousand copies, an amazingly high number for a juvenile novel. Six of her novels have been reprinted by various book clubs, and librarians and book dealers are well aware of the popularity of Ms. Norton's books with both young and old. Her works have been published in nine foreign languages—French, Spanish, German, Japanese, Italian, Hungarian, Russian, Arabic, and Portuguese—and two books, *Star Ranger* (A16) and *The Sword is Drawn* (A04), have been reproduced as talking books for the blind. The former has also been published in Braille.

To classify Ms. Norton as strictly a science-fiction and fantasy writer or as a juvenile author would be an error. Her genres range far beyond the confines of only a few types of literature. Her canon includes mysteries, westerns, gothic fiction, historical novels, adventure stories, a biography, poetry, and non-fiction (see Appendix I), as well as science fiction and fantasy.

Recently, and as this bibliography indicates, Ms. Norton's works have been receiving unusual attention. In 1977 Gregg Press reissued seven of the works in her Witch World series in their first hardback appearances—*Witch World* (A52), *Web of the Witch World* (A55), *Year of the Unicorn* (A60), *Three Against the Witch World* (A58), *Warlock of the Witch World* (A68), *Sorceress of the Witch World* (A72), and *Spell of the Witch World* (A97)—with a long introduction by Sandra Miesel (D59). The same publishing firm has reissued seven of her earlier novels in hardcover: *Sargasso of Space* (A24), *The Crossroads of Time* (A27), *Plague Ship* (A28), *Secret of the Lost Race* (A38), *Voodoo Planet* (A39), *The Sioux Spaceman* (A41), and *Star Hunter* (A45), again with an introduction by Sandra Miesel (D65). In addition, Fawcett Books has recently paid $336,000 (not $393,000 as incorrectly reported in *Locus*, December 1977, p. 1) for the paperback rights to eighteen of her earlier novels that were originally published by Harcourt, Brace and last owned by Ace Books.

Despite her popularity and the range of her fiction, she has never received the critical acclaim that might be expected in the case of so creative and prolific a writer. Both Barry McGhan (D27) and Donald A. Wollheim (D41) have examined this unexpected phenomenon. McGhan speculates

that the reasons for this neglect are the general critical disinterest in fantasy, and the classification of Ms. Norton's works as escapist and juvenile literature. While also noting that her books have been restrictively labeled as "young adult," Wollheim points to more concrete concerns: Ms. Norton's works have rarely appeared in the popular science-fiction magazines, and her poor health has prevented her from promoting herself, as many authors do, at the numerous science-fiction conventions that are regularly held throughout the country each year. In addition to the reasons advanced by these two critics, another may be suggested: she is a superb storyteller, and her command of the narrative form is at times so effective that even the most critical reader becomes too enthralled to reflect and analyze.

Yet, while Ms. Norton's work has generally escaped critical attention until very recently, her career has not gone unrecognized or unrewarded. As early as 1944, *The Sword is Drawn* (A04) was a Literary Guild choice, and in 1946 it received a special award from the Dutch government. In 1966 *Moon of Three Rings* (A62) was a Junior Literary Guild selection. Her edition of Malcolm Jameson's *Bullard of the Space Patrol* (A10) received the Boys' Clubs of America Medal in 1951, and the same group awarded her a Certificate of Merit for *Night of Masks* (A53) in 1965.

Ms. Norton's awards have been especially noteworthy since she has been the first of her gender to receive certain of them. In 1963, at Westercon XVI, a major gathering of science-fiction fans designated her as the first woman to be presented with the Invisible Little Man Award for sustained excellence in science fiction. Southern fandom made her the first female recipient of the Phoenix Award for overall achievement in 1976, and she was the first woman writer inducted into the late Lin Carter's Swordsmen and Sorcerers' Guild of America, "S.A.G.A.," the group that regularly contributes to Carter's Flashing Swords anthologies (Lin Carter, *Imaginary Worlds: The Art of Fantasy* [New York: Ballantine Books, 1973], p. 149).

Indeed, world-wide science-fiction fans and readers have paid tribute to Ms. Norton by nominating *Witch World* (A52) and "Wizard's World" (A69) for the prestigious Hugo Awards in 1964 and 1968, respectively. It was just recently, in 1977, that the same group gave her writing its highest tribute. She followed J. R. R. Tolkien, Fritz Leiber, and L. Sprague de Camp as the fourth writer and the first woman to be honored by a special award on the Hugo ballot, the Gandalf. This memorial to J. R. R. Tolkien honors Ms. Norton for her lifetime achievement in fantasy. The award is clearly the single most significant tribute that a fantasy writer can receive.

Even in light of the mystery of the critical neglect as opposed to her popular acclaim, a more challenging enigma is inherent in Ms. Norton's enormous range and output. What kind of a person and author can generate eighty-seven novels and twenty-eight short stories to date in a sustained career of over forty-four years and show no signs of creative exhaustion?

Andre Norton was born Alice Mary Norton in Cleveland, Ohio, on February 17th, 1912, to Adalbert Freely Norton and Bertha Stemm

Norton. She was a late child, born seventeen years after her sister. An apparent result of this was that she never developed close relationships with her siblings or her contemporaries and was influenced primarily by her parents. Her early family life was dominated by her mother's strong literary interests, and before Ms. Norton could read herself, her mother would read to her and recite poetry as she went about various household chores. Ms. Norton was first introduced to literature by gifts of most of Howard Roger Garis' Uncle Wiggley books and the legacy of a copy of *The Swiss Family Robinson*. Later, good grades in school were rewarded by copies of Ruth Plumly Thompson's Oz books, and her young imagination was also stimulated by playing with the miniature animals that were about the house, an occupation that clearly is a foreshadowing of the delightful animal creations that fill many of her works. The maternal influences continued well into Ms. Norton's career, as her mother did all her proofreading and served as a critic-in-residence. This influence was appropriately honored in 1969 when Ms. Norton completed her late mother's autobiographical novel, *Bertie and May* (A74).

The Norton family's commitment to reading and literature was fortified by a strong sense of family history. Both Gary Alan Ruse's and Paul Walker's interviews (D60 and D34) point out the importance of this heritage in Ms. Norton's development. Her mother's family had been Bounty Land settlers in Ohio, and her great-grandfather had married a Wyandot, named Elk Eyes, to fully ratify his land claim. In fact, theirs was the first such union between a Caucasian and an Indian in the territory. Her father's fascination with westerns and accounts of the early trail drives can be traced to his birth in the Indian territory that is now Nebraska, to his witnessing the Indian uprising of 1866, and to the fact that he lived in Ellsworth, Kansas, shortly after the time of Wyatt Earp. Another member of Ms. Norton's father's family had the dubious distinction of being a witness in the Salem witch trials. In addition, three of her mother's uncles had served in the Civil War: one of them was imprisoned in Andersonville, and another died at Gettysburg. It was this rich family history that inspired Ms. Norton's early historical novels, such as *Follow the Drum* (A03), *Ride Proud ,Rebel!* (A44), *Stand to Horse* (A30), and *Rebel Spurs* (A49). *Rebel Spurs* is based on the actual life of a rancher who fortified his ranch, allied himself with the Pima Indians, and stood off numerous Apache attacks. *Ride Proud, Rebel!* is derived from the Civil War diary of one John Smith, and the period of early feminine rule in colonial Maryland is the source for *Follow the Drum*.

Ms. Norton's writing career began while she was attending Collingwood High School in Cleveland, Ohio. Under the tutelage and guidance of an English teacher, Miss Sylvia Cochrane, she edited and contributed to the high school publication, *The Collingwood Spotlight*. A solitary teenager, she devoted much of her extracurricular time to editing and writing, and it was during this early formative period that she wrote *Ralestone Luck* (A02), which was later rewritten and published as her second novel in 1938.

After graduating from high school, Ms. Norton attended Flora Stone Mather College of Western Reserve University (now Case Western Reserve) for a year from the fall of 1930 to the spring of 1931, with the intention of becoming a history teacher. The depression quickly put an end to the luxury of a full-time college education. She was forced to find work and help support the household. For the remainder of her college education, Ms. Norton had to be content to exhaust the evening courses in journalism and writing that were offered by Cleveland College, the adult division of Western Reserve University. She was soon employed by the Cleveland Library System and concentrated on children's literature. Her involvement in the children's story hour would later bear fruit. *Rogue Reynard* (A06), based on the medieval beast fables; *Huon of the Horn* (A11), based on a medieval French romance entitled *Boke of Duke Huon of Burdeux*; and *Steel Magic* (A57), based on the Arthurian legends, were the results of stories she had prepared for the children.

While much of her time was spent as an assistant librarian in the children's section of the Nottingham Branch Library in Cleveland, she became something of a trouble-shooter for the entire system and worked in thirty-eight of the forty branches at one time or another. In the eighteen years from 1932 to 1950 that she worked for the library system, her lack of a degree prevented her from advancing as her ability might have dictated, and the lack of employment opportunities during the depression forced her to stay and endure a number of discomforts that made her tenure unpleasant. Nevertheless, despite financial difficulties and the excessive responsibilities of the library position, in 1934 she published her first novel, *The Prince Commands* (A01), a historical fantasy, and went on to publish eight more novels and two short stories before she left the library system in 1950.

It was when she published her first novel that Ms. Norton began to legally use the name Andre, and she has continued to use it exclusively. Thus, the citation of "Andre" as a pseudonym for her given name, Alice Mary, in a number of bibliographies, biographies, and critical accounts is in error. In actuality, the only pseudonym Ms. Norton has ever used is Andrew North. (She did use "Allen Weston" once when collaborating with Grace Allen Hogarth—See A20.) This name change was implemented primarily because she expected to be writing for young boys, and she felt that the change would increase the marketability of her work in this traditionally male market. This was an added asset when she entered the masculine-dominated science-fiction field.

During Ms. Norton's one brief absence from the Cleveland Library, she owned and managed a book store and lending library called the Mystery House in Mount Ranier, Maryland, in 1941. While the bookstore was a failure, it was at much the same time, 1940 to 1941, that she engaged in an activity of greater importance. During this period, she worked as a special librarian in the cataloging department of the Library of Congress.

She was specifically involved in a project related to alien citizenship. The project was abruptly terminated by the beginning of World War II, but the skills learned augmented and developed the meticulous research that characterizes all Ms. Norton's fiction. In addition, her experience in the Library of Congress later was valuable background for the association with the World Friends' Club in Cleveland that resulted in her fourth novel, *The Sword is Drawn* (A04), in 1944. This espionage novel chronicles the activities of the Dutch underground during World War II and was written at the request of the World Friends' Club. It was so successful that the Dutch government awarded Ms. Norton an enamel plaque in 1946 for the book's authenticity and for its portrayal of the valiant efforts of the underground. Additional research, letters supplied by the Dutch, and over two hundred photographs supplied by one of the leaders of the underground led to the publication in 1949 of a second novel focusing on Dutch history in the Indies and Nazi and Japanese war holdouts in the islands, *Sword in Sheath* (A09). A third novel in the series, *At Swords' Points* (A17), was published in 1949. It draws on Ms. Norton's fascination with jewelry and its often bloody history. The novel centers on the noble efforts of a young man to solve the mystery of his brother's death, is also set in the Netherlands, involves the active remnants of the World War II underground, and focuses on the recovery of a set of jeweled miniatures of knights in armor. A fourth novel in the series, "Sword Points South," set in South America and drawing on the activities of the emerald trade, remains unfinished and unpublished.

While Ms. Norton did leave the Dutch setting and history behind, the elements of mystery and intrigue that are the strongest aesthetic features of the three published novels in the Sword series continue as major characteristics in her later work. Her fascination with jewels and talismans, and with their histories and occult properties, continues as principal images in *The Zero Stone* (A73), the Witch World series (see Appendix II), *Wraiths of Time* (A123), and her gothic novels, particularly *The White Jade Fox* (A118) and *The Opal-Eyed Fan* (A124). Often these jewels or talismans are the sources of unusual power. Strange black stones and cloudy crystals generate life and power in *The Zero Stone* and its sequel, *Uncharted Stars* (A78). In Ms. Norton's justifiably heralded Witch World series, special cloudy crystals are used by the matriarchal witches to focus their sorcerous powers, and in one of the short stories in this series, "Dragon Scale Silver" (A91), a magically conceived silver bowl is the link between two twins. Throughout Ms. Norton's work, such objects almost always have special significance.

After Ms. Norton left the Cleveland Library System in 1950, she worked as a reader for Martin Greenberg at Gnome Press until 1958. Her most striking memory of these eight years is of her reading the manuscript of Murray Leinster's *The Forgotten Planet* (1954).

Most importantly, it was during this period that Ms. Norton wrote her first science-fiction novel, *Star Man's Son 2250 A.D.* (A12). Her begin-

ning was auspicious. Donald A. Wollheim, the publisher of the novel, explains in *The Universe Makers: Science Fiction Today* (New York: Harper & Row, 1971) that the novel had sold over one million copies in the Ace paperback edition as of 1970. However, this was not, as many believe, her first excursion into science fiction and fantasy. Early in her career, in 1947, she had published a short story in a short-lived pulp magazine, *Fantasy Book*, entitled "People of the Crater" (A05). This story was later included as "Garin of Tav" in one of her most successful collections, *Garan the Eternal* (A93). In addition, in 1949 she had edited the first of four science-fiction anthologies, for the World Publishing Company in Cleveland. This first being a collection of Malcolm Jameson's stories, *Bullard of the Space Patrol* (A10).

It was the freedom afforded by her position with Gnome Press that allowed Ms. Norton to concentrate more fully on her writing career, and in 1954 alone she published six novels and another edited anthology, *Space Pioneers* (A21). When she left Gnome in 1958, she had written twenty-three novels. After that, the increased income from her book sales and her relationship with Ace Books, as described by Lin Carter in "Andre Norton: A Profile" (D19) and in *Imaginary Worlds*, allowed her to write on a full-time basis. This she has done with marked enthusiasm. In the period from 1958 to 1978, she added sixty-seven novels, three short story collections, five edited anthologies, and twenty-three short stories (a genre she professes no special skill in) to her already extensive canon.

In November of 1966, her uncertain health necessitated a move to Florida. She now lives there with her cats, large library, and figurines. She spends much of her time writing and reading, and her active mind and excellent hospitality belie any thought that she will yield to her family's encouragement that she retire.

Andre Norton quickly contends that her life has not been interesting. Yet, the richness of her writing seems to contradict that self-evaluation. Her life does seem devoid of great adventures, but it has obviously generated a wealth of material for her creative abilities. Part of the answer to this apparent contradiction can be clarified by recalling John Keats' "On First Looking into Chapman's Homer." Keats' "negative capability"—the ability to project the mind into art—successfully captures the quality of Ms. Norton's vicarious experience while also touching on her fascination with history:

> Much have I travell'd in the realms of gold,
> And many goodly states and kingdoms seen;
> Round many western islands have I been
> Which bards in fealty to Apollo hold.
> Oft of one wide expanse had I been told
> That deep-brow'd Homer ruled as his demesne;
> Yet did I never breathe its pure serene
> Till I heard Chapman speak out loud and bold:

Then felt I like some watcher of the skies
When a new planet swims into his ken;
Or like stout Cortez when with eagle eyes
He star'd at the Pacific—and all his men
Look'd at each other with a wild surmise—
Silent, upon a peak in Darien.

So too, Ms. Norton has spent a lifetime industriously extending herself into reading and researching, and her excellent memory has let little of this information escape. She candidly expresses this enthusiasm in her introduction to C. J. Cherryh's *Gate of Ivrel*:

> There are those among us who are compulsive readers—who will even settle a wandering eye on a scrap of newspaper on the bus floor if nothing better offers. Books flow in and out of our lives in an unending stream. Some we remember briefly, others bring us sitting upright, tense with suspense, our attention enthralled until the last word on the last page is digested. Then we step regretfully from the world that author has created, and we know that volume will be chosen to stand on already too tightly packed shelves to be read again and again (C103, p. 7).

Ms. Norton's home is indeed filled to overflowing with books on a wide range of subjects, and one of her leisure time activities is perusing book catalogs for additional titles that pique her varied interests. A quick survey of her "too tightly packed shelves" reveals books on such subjects as the English longbowman; Victorian architecture and gardens; speculative archaeology, especially the works of T. C. Lethbridge; folk tales, including Stith Thompson's multi-volume index to folk tales; the occult and witchcraft; cats; general history; and Icelandic and Anglo-Saxon sagas.

Despite her insistence that she keeps only titles she wants to read more than once, her collection of fantasy, science fiction, and general fiction is imposing. Among her admired authors are H. Beam Piper, James H. Schmitz, Susan Cooper, Edgar Rice Burroughs, David Mason, Alan Garner, C. J. Cherryh, A. Merritt, Cordwainer Smith, H. Rider Haggard, J. R. R. Tolkien, Evangeline Walton, Poul Anderson, Dornford Yates, Roger Zelazny, Richard Adams, Ruth Plumly Thompson, L. Sprague de Camp, Keith Laumer, Anne McCaffrey, and William Hope Hodgson. Some of her selections reflect admiration and pleasure. Others—most notably Haggard, Piper, Yates, Thompson, Mundy, and Hodgson—constitute sources and influences. All demonstrate a considerable range of interests that makes the study of her sources a journey into a kaleidoscope.

Her debt to Burroughs, Haggard, Merritt, and Mundy lies in her aesthetic commitment to the value of a clear, fast-moving plot. Contributing to this commitment to the value of strong narrative was her discovery of the works of Henry Fielding, Daniel Defoe, Tobias Smollett, and Samuel

Richardson while she was attending Western Reserve University, an event she retells vividly even though some forty-seven years have passed since its occurrence. In the same vein, her mother's collection of nineteenth-century American and Victorian novelists also made a marked contribution to her narrative development, and it was her mother's library and her own affections that generated her scholarly study of the works of Maria Susanna Cummings, Mary Jane Holmes, Emma Dorothy Eliza Nevitte ("E.D.E.N.") Southworth, Elizabeth Wetherell (pseudonym for Susan Bogart Warner), and Augusta Jane Wilson, the nineteenth-century American novelists whom Nathaniel Hawthorne, envious of their financial success, called "those damned scribbling women." (Unfortunately, the only manuscript of this book was loaned to a college professor some years ago and never returned.)

More specifically, William Hope Hodgson's *The Night Land*, a book Ms. Norton was instrumental in having included in Lin Carter's Ballantine Adult Fantasy Series, is the direct source for *Night of Masks* (A53). *Night of Masks* resulted from her fascination with Hodgson's dark world, and her setting and characters benefit from the innovative concept of a world lit by an infrared sun. *Dark Piper* (A70) is based on the folk tale of the Pied Piper of Hamelin, and *Year of the Unicorn* (A60), part of the shape-changer subdivision of the Witch World series, is derived from the tale of Beauty and the Beast. John Rowe Townsend has correctly pointed out that *Star Guard* (A25) is a retelling of Xenophon's *Anabasis* (D32, p. 145). The strange outsized ring in *The Zero Stone* (A73) was inspired by a description of an odd piece of jewelry, meant to be worn with armor, in an off-beat book called *The Hock Shop* (1954) by Ralph R. Simpson, and the Time Trader novels (see Appendix II) had their inception in the minimal historical information concerning the Bronze Age Beaker Traders as described in Paul Herrmann's *Conquest by Man* (1954).

The Jargoon Pard (A106), another novel focusing on the Witch World shape-changers, can be accounted for by Norton's aforementioned fascination with jewelry, and the protagonist's characteristics are the result of a special reading of the Tarot cards. *Shadow Hawk* (A40), a historical fantasy set in Ancient Egypt, emerged from Ms. Norton's reading of the works of Joan Grant, specifically *Winged Pharaoh, Eyes of Horus*, and *Lord of the Horizon*. *Scarface* (A08), a juvenile adventure story, is based on the diary of a Dutch physician who was captured by pirates, and it draws heavily on the life of Henry Morgan as well. To change a western into a science-fiction novel and write *The Beast Master* (A36) and its sequel, *Lord of Thunder* (A48)—novels that describe the poignant quest for self and home by a Navaho Indian after Terra has been destroyed—Ms. Norton obtained Navaho phrase books and linguistic studies from the Government Printing Office in Washington, D.C.

Ms. Norton's Magic series is an example of her ability to derive structure as well as content from her sources, and each volume in the series uses a single, central image to unify and generate the action. In *Steel Magic*

(A57), the utensils in a picnic basket become the talismans of Arthurian Britain and the means of entry into a fantasy world. *Octagon Magic* (A66) uses an elaborate doll house to propel the heroine into a world of historical conflict. *Lavender-Green Magic* (A107) uses a maze; *Dragon Magic* (A90), a puzzle; *Red Hart Magic* (A121), a peep show that Ms. Norton discovered in a picture of an Elizabethan inn in a history of the period; and *Fur Magic* (A71), an Indian medicine bag and the Indian legend of the changer.

In addition to these sources for individual works, one of the predominant influences in Ms. Norton's fiction is the psychic pseudo-science of psychometry. This activity is formally defined as the detection by a sensitive of the residue that exists in an artifact that has been handled by man through the ages. This residue contains events, human emotions and experiences, and, in the case of religious or mystical objects, psychic power. The process is more fully defined by Ms. Norton's female protagonist, Ziantha, in *Forerunner Foray*:

> For a long time it had been a proved fact that any object wrought by intelligence (or even a natural stone or similar object that had been used for a definite purpose by intelligence) could record. From the fumbling beginnings of untrained sensitives, who had largely developed their own powers, much had been learned. It had been "magic" then; yet the talent was too "wild," because all men did not share it, and because it could not be controlled or used at will but came and went for reasons unknown to the possessors (A99, p. 50).

This concept is further dramatized in *Wraiths of Time* (A123). A young Black girl has been thrown into a parallel universe where the ancient Nubian kingdom of Meroè has never fallen and has continued to develop its psychic powers for two thousand years. The young protagonist, Tallahassee Mitford, is drawn back to replace a dead princess in a struggle between good and evil. The keys to success for the virtuous advocates of the "Power" are a crystal ankh and a staff. Tallahassee is the wielder of the staff, and both talismans are the products of the concentrated psychic powers of the people of Meroè. Early in the book, another character explains the significance of such objects to Tallahassee:

> "There was a strong belief in the old African kingdoms that the soul of a nation could be enclosed in some precious artifact. The Ashanti war with England a hundred years ago came about because an English governor demanded the King's stool to sit on as a sign of the transferral of rulership. But even the King could not sit on that. Sitting on a floor mat, he might only lean a portion of his arm upon it while making some very important decree or when assuming the kingship. To the Ashanti people the stool contained the power of all the tribal ancestors and was holy; it possessed a deeply religious as well as a political significance—which the English did not attempt to find out before they made their demands" (A123, pp. 5-6).

Ms. Norton's original source for this concept is the works of T. C. Lethbridge. Pertinent works include *E S P: Beyond Time and Distance*, *The Monkey's Tail: A Study in Evolution and Parapsychology*, *A Step in the Dark*, and *The Legend of the Sons of God: A Fantasy?* Some of this influence is condensed in Ms. Norton's *Merlin's Mirror* (A115), and in this work, both the wizard Myrddin/Merlin and the king Arthur are the sons of the union between earthly woman and extraterrestrial artificial insemination. In combination with the novel's account of ancient alien visits to Earth is Merlin's ability to sense the alien residue in various objects, such as the stones of Stonehenge. To recover Excalibur, a sword made of star metal, Merlin uses a small scrap of star metal as a divining rod. Thus, through their commonality, the scrap is attracted to the sword. An even more striking example of psychometry is the basis for *Forerunner Foray* (A99). Ziantha, a young sensitive and thief, is compulsively drawn to an artifact. It appears to be only a stone, but hidden within is a gem of enormous psychic power that holds the memory of and the key to a prehuman tomb containing untold wealth.

Yet, as significant as Lethbridge's books were to Ms. Norton's initial interest in psychometry, she did not accept his premises at face value. Rather, she has herself conducted rigorous experiments with admitted sensitives. The result is that Ms. Norton now entertains a doubting acceptance of the concept. More important than the validity of psychometry to an understanding of her fiction, however, is that psychometry provides the bridge between two of her dominant interests and two of the dominant characteristics of her work: history and speculative archaeology. This bridge is defined by the character Lantee in *Forerunner Foray* as he explains to the protagonist Ziantha how the two of them should find themselves transported to the distant past:

> "Now what is this about the focus-stone? Apparently some trick of psychometry hurled us back into this [the past], and the more I know how and why the better" (A99, p. 116).

Ms. Norton fully exploits this "trick" in many of her novels, far too many to list, in fact. Whether it be the artifacts of alien visits to ancient Earth or the concept of the prehuman Forerunners whose tantalizing artifacts are scattered through the universe and provide so many of Ms. Norton's works with an epic scope and a brooding mystery, the important thing is that psychometry is one of the major ways by which Ms. Norton can exercise her inclination toward the intriguing elements of history and combine them with elements of either science fiction or fantasy. The necessity of the retention of the value of the past within Ms. Norton's aesthetic is aptly dramatized by the enigmatic and magical Miss Ashemeade, who can accurately be identified as the Norton persona in the fantasy novel *Octagon Magic*:

"There was a lady in England," Miss Ashemeade replied, "who once said that it was as disgraceful for a lady not to know how to use a needle as it was for a gentleman to be ignorant of how to handle his sword." She wiped her fingers on a small napkin. Lorrie did not know just what was expected of her, but she said after a moment's pause:

"Gentlemen do not have swords any more."

"No. Nor do many ladies use needles either. But to forget or set aside any art is an unhappy thing" (A66, p. 55).

In her essay "On Writing Fantasy," Ms. Norton affirms the importance of the functional use of the past in her works and further delineates the humanistic elements of history that she likes to represent.

But the first requirement for writing heroic or sword & sorcery fantasy must be a deep interest in and a love for history itself. Not the history of dates, of sweeps and empires—but the kind of history which deals with daily life, the beliefs, and aspirations of people long since dust (C94, p. 8).

Vivian de Sola Pinto, in his excellent study *Crisis in English Poetry 1880-1940* (rev. ed., New York: Harper Torchbooks, 1958), provides a creative pattern that accurately identifies how creativity can exist in a seemingly uneventful life like Andre Norton's. He defines two journeys by which the author can find full expression in his or her art: the outer voyage and the inner voyage. For an author of science fiction, fantasy, or any other highly fictive literature to make a strong outer or mimetic voyage to actual places or events is absurd. The very nature of such literature makes such experience clearly impossible. However, the idea of inner voyage does provide a clear means of ascertaining the nature of Ms. Norton's Keatsian experience. De Sola Pinto quotes C. F. G. Masterman's *Condition of England* (1909) for a definition of this inner voyage: "a voyage within and across distant horizons and to stranger countries than any visible to the actual senses" (p. 13). This is the nature of the innovation, scope, and settings of Ms. Norton's fiction, and its intent is a direct indication of her mental activity. Ms. Norton's life, then, has been limited only by the parameters of her own interests, and her literary output clearly shows that her inner voyages have taken her to "distant horizons" and lands strange and vast.

It is not surprising, then, that the world of Andre Norton's fiction is cosmic in scope. At the beginning of *Merlin's Mirror*, Ms. Norton sets just such a scene as a backdrop for the tasks of the protagonist Myrddin:

Time had been swallowed, was gone, and still the beacon kept to its task, while outside the cave nations had risen and decayed, men themselves had changed and changed again. Everything the makers of the beacon had known was erased during those years, destroyed by the very action of na-

ture. Seas swept in upon the land, then retired, the force of their waves taking whole cities and countries. Mountains reared up, so that the shattered remains of once-proud ports were lifted into the thin air of great heights. Deserts crept in over green fields. A moon fell from the sky and another took its place (A115, p. 5).

Indeed, her characters range through galaxies and are embroiled in issues and conflicts of universal and elemental concern. Their quests and actions are intermingled with essential and critical patterns of being, both for themselves and others. The characters are arrayed in a cosmos filled with strange races and alien climes, and the narratives grow from a deep tradition, exist in a momentous present, and face a vital future.

Surprisingly, even though many of her novels are set in the future, she has no special affection for the technological, and, in fact, science is most often the antagonist in her fiction. In the Janus series, an alien computer is the villain, and in the Witch World series (see Appendix II for full listing of series), the dreaded Kolder are a scientific race from a parallel universe. Ms. Norton, as quoted in Rick Brooks' "Andre Norton: Loss of Faith," makes her stance quite clear:

> "Yes, I am anti-machine. The more research I do, the more I am convinced that when western civilization turned to machines so heartily with the Industrial Revolution…, they threw away some parts of life which are now missing and which the lack of leads to much of our present frustration" (D29, p. 22).

However, although it is unusual that an author who writes so much science fiction should be anti-technological, it is not at all odd when one realizes what is of primary importance in Ms. Norton's fiction. The scientific and the mechanistic settings exist only to provide a context for her real emphases: plot and character. People, their lives, and their futures are her central concerns. As John Rowe Townsend points out, "Miss Norton handles her gadgetry with great aplomb. She never draws special attention to it; it is simply there" (D32, p. 148). Quite simply, her futuristic settings provide the often violent, comprehensive, and active arenas for her dramas. The fact that they may be set in the future is a minor part of her work. Rather, she dwells primarily on the chronicles of beings and their journeys through existence.

Structurally, her stories move quickly through these settings, and there is little doubt that she is a skillful master of narrative. Her storytelling is always complete, leaving few, if any, loose ends. Her effective use of chronology and causality move the reader easily into and through events that out of context may appear implausible, and her writing is uniformly credible. In her essay "On Writing Fantasy," Ms. Norton captures the effect of her own narrative when she reflects on the achievements of writers she herself admires:

There [the combination of history and imagination] we can find aids in novels—the novels of those inspired writers who seem, by some touch of magic, to have actually visited a world of the past. There are flashes of brilliance in such novels, illuminating strange landscapes and ideas. To bring to life the firelit interior of a Pictish broch (about whose inhabitants even the most industrious of modern archeologists can tell us little) is, for example, a feat of real magic (C94, p. 8).

Much of the effectiveness of Norton's narrative structure stems from her utilization of the comic mode or the mythic patterns of spring that Northrop Frye explains so cogently in *The Anatomy of Criticism*. Her protagonists are involved in a struggle and must triumph over an unlawful, established society to survive. Frequently, the protagonists must undergo a rite of passage to find self-realization, and the completion of the comic mode, or "triumphant comedy," as Frye calls it, demands the establishment of a new order and the acquisition of freedoms and new insights into the nature of existence. Thus, in *Star Gate* (A34), the half-human, half-alien Cim must deny the society of his human mother and come to terms with his own manhood and his mixed heritage to find a place in the advanced society of his alien father. Furtig, the mutated cat and protagonist of *Breed to Come* (A88), discovers that his existence is dependent upon his ability to discover his own potential and confront the mythology of his long-departed human masters, especially when they suddenly return. In *Star Guard* (A25), *The Zero Stone* (A73), and *The Stars Are Ours!* (A22), the protagonists must overcome monolithic and authoritarian societies to reach their goals, and in *Judgment on Janus* (A50) they must defeat the rigid bigotry of the patriarch Skywalkers to preserve the truer humanity of the alien Iftcan. Thus, Ms. Norton's fiction dwells on one of the most poignant and appealing narratives in literature: the success and elevation of the innocent. In this process, bondages and wastelands are overthrown, new and generative orders are established, and the protagonists are ennobled.

The passage of Ms. Norton's characters through this process constitutes her themes, and their concerns, needs, and successes are the major ideas that her fiction presents. One of the clearest examples of her use of character to express a pattern of experience is *Sorceress of the Witch World* (A72). Kaththea, the protagonist, is nearly destroyed when she mistakenly gives her love, innocence, and sorcerous powers to an evil adept, Dinzil. She must pass through the darkness of her own fear to find rebirth. To save her family, she undergoes a rite of passage and passes from a degenerate state to a generative one, the archetypal quest for salvation. Ultimately, she opens herself to the virtuous archmage Hilarion, one of the enormously powerful "Old Race" of the Witch World series, and is elevated to a new level of awareness:

> Thus I was forced to open my eyes, not on the terrible blinding chaos I had thought, but to see who stood by me. And I knew that this was not one of Dinzil's breed, those who do not give, only take. Rather it was true that between *us* there was neither ruler nor ruled, only sharing. There was no need for words, or even thoughts—save a single small wonder quickly gone as to how I could have been so blind as to open the door to needless fear (A72, p. 220).

This pattern is much like the one found in certain nineteenth-century British Romantics and is especially similar to the passage from innocence to experience to higher innocence in William Blake's prophetic books. In view of Ms. Norton's commitment to life and generation, it is natural that Rick Brooks should observe that "... the chief value of Andre Norton's fiction may not lie in entertainment or social commentary, but in her 'reenchanting' us with her creations that renew our linkages to all life" (D29, p. 16). This she does accomplish, and her strong characterization is the vehicle for the humanistic themes in her work.

Because Ms. Norton's characters come in all sizes and shapes, their most important qualities are internal, and the distinctions among human, alien, and animal simply do not apply. In *The Beast Master* (A36) and *Lord of Thunder* (A48), the native and admirable Norbie race possesses horns, and the protagonist's best friends are telepathic animals. The long-lived Zacathans, a reptile race, are the honored and wise historians of the galaxy, and their studies of the pre-human Forerunner civilizations give depth to a number of Ms. Norton's novels, most notably those in the Shann Lantee and Zero Stone series (see Appendix II). There are also large numbers of superior telepathic animals in Ms. Norton's fiction; frequently, they are nobler than humanity. Their roles range from the semi-sentient loyalty of Vorken, the hideous winged reptile of *Star Gate* (A34), to the intelligent kinkajou, cats, and foxes of *Catseye* (A43) who are the salvation of the human Troy. Nowhere in Ms. Norton's fiction is this ecumenical attitude more explicitly stated than in *Star Guard*, as Terran mercenaries, in conflict with their own kind, find the first sign of what will be their new allies:

> Kana eyed the slit speculatively. It was too narrow for the length if it were fashioned to accommodate a humanoid. It suggested an extremely thin, sinuous creature. He did not feel any prick of man's age-old distaste for the reptilian—any reminder of the barrier between warm-blooded and cold-blooded life which had once held on his home world. Racial mixtures after planet wide wars, mutant births after the atomic conflicts, had broken down the old intolerance against the "different." And out in space thousands of intelligent life forms, encased in almost as many shapes and bodies, had given "shape prejudice" its final blow (A25, p. 151).

In fact, this non-prejudicial attitude in regard to types of being has been present in Ms. Norton's cosmos from the very beginning, and it has

been prophetic in its anticipation of at least one contemporary issue. Amanda Bankier, in the feminist fanzine *The Witch and the Chameleon* (D38), pays tribute to Ms. Norton's humanistic foresight when she says:

> For a long time before concern over sexism became wide-spread, Andre Norton had been quietly providing us with strong female characters, and exploring the woman's side of sexist societies in her fantasies and science fiction (D38, p. 3).

In addition to the insignificance of shape and the importance of internal quality, Ms. Norton's leading characters are at odds with the social order. For example, Andas, in *Android at Arms* (A85), stands alone against an entire royal dynasty. Also, they are frequently outcasts, disenfranchised, alone with only themselves, their ethics, and a very few close allies. Often, they are hunted or hounded by the authorities, as are Murdoc Jern and Eet in *The Zero Stone* (A73) and *Uncharted Stars* (A78). Sometimes they have been exiled from their own kind: Fors flees his clan after he has been denied his heritage in *Star Man's Son 2250 A.D.* (A12). Other times, it is simply that a holocaust or a conflict has left them alone or separated, as in *Storm Over Warlock* (A42) and *Ordeal in Otherwhere* (A54). Finally, and most often, what sets the protagonists apart are special powers. Ziantha's distinctive psychic ability, in *Forerunner Foray*, has been a source of persecution and alienation for her for so long that she is still suspicious even when confronted with one of her own kind:

> But this was a man [Lantee] with a talent akin to hers, equal, she believed. And she could not forget the actions on Turan's [Lantee's] time level that had endangered them both, that they had shared as comrades, though he was now the enemy. He made her feel self-conscious, wary in a way she had not experienced before (A99, p. 266).

Whatever the reasons for their separation, Ms. Norton's characters are uniformly isolated and driven. As a result, it is not unexpected that fear is an emotion and motive common to all of them. The tragic Hosteen Storm, of *The Beast Master*, his native Terra destroyed, is an accurate model for the agonizing terror that almost paralyzes many of the characters:

> He would not remember! He dared not! Storm's hands balled into fists and he beat them upon his knees, feeling that pain far less than the awaking pain inside him. He was cut off—exiled— And he was also accursed, unless he carried out the purpose [revenge] that had brought him here (A36, p. 60).

And the characters have good reasons to fear. As if the hostile environments and antagonistic human agencies were not enough, unseen and

metaphysical dangers also exist, and they are far more threatening than the physical. In the Witch World series, the fantasy genre and its perspective allow the removal of physical appearances and demonstrate that the real fear in Ms. Norton's fiction is not that of physical harm, but of the extinction of the self. In *Witch World*, Jaelithe, the female protagonist, warns of just such a danger in the blasphemous and inhuman weapon of the scientific Kolder:

> "A Man is three things." It was the witch who spoke now. "He is a body to act, a mind to think, a spirit to feel. Or are men constructed differently in your world, Simon? I can not think so, for you act, you think, and you feel! Kill the body and you free the spirit; kill the mind and ofttimes the body must live on in sorry bondage for a space, which is a thing to arouse man's compassion. But to kill the spirit and allow the body, and perhaps the mind to live—" her voice shook, "that is a sin beyond all comprehension of our kind. And that is what has happened to these men of Gorm. What walks in their guise is not meant for earthborn life to see! Only an unholy meddling with things utterly forbidden could produce such a death" (A52, p. 51).

It is undoubtedly their alien natures and their fears that govern the characters. Yet, a more subtle restlessness shapes their destinies. Just as Ms. Norton's own life has been a pursuit of knowledge, so too her characters possess a yearning for understanding. They seek a place for themselves and desire a healing and shaping of self through discovery. Gillan of *Year of the Unicorn* feels this unprovoked need and restlessness:

> How does one know coming good from coming ill? There are those times in life when one welcomes any change, believing that nothing can be such ashes in the mouth, such dryness of days as the never altering flood of time in a small community where the outside world lies ever beyond gates locked and barred against all change (A60, p. 5).

Alone, frightened, alienated, threatened, searching—Ms. Norton's characters are nevertheless always admirable, and they do have and do find positive virtues. Their own ethical systems may shake and weaken, but ultimately they are vindicated and are more attractive for their frailty. Despite their varied and mutated shapes and talents, they achieve a genuine nobility, a nobility always truer than that of the more "normal" types around them. They are healers of themselves and those around them, and they gain the freedom that only comes from the recognition of responsibility to self. Frequently, their resolutions are androgynous: within themselves or in union with another, they find the ideal combination of male and female characteristics. Most of all, they discover a sanctity of ideas and ethics, and they recognize their own places within the patterns and rhythms of elemental law and carry that recognition forward into a hopeful future. These patterns and rhythms are in nature, but nature is only one of their manifestations, only a

part of the necessary interrelationships that are the foundations of a complete and proper realization of self. Hosteen Storm, in *The Beast Master*, feels the full power of this link between himself and elemental order when he stands alone against a group of hostile aliens:

> Storm was no singer, but somehow the words came to his tongue, fitted themselves readily together into patterns of power so that the Terran believed he walked protected by the invisible armor of one who talked with the Faraway Gods, was akin to the Old Ones. He could feel the power rise and possess him. And with such to strengthen him what need had a man for other weapons? (A36, p. 172)

Ultimately, all the qualities of Ms. Norton's settings and characters produce a fiction which realizes the value of the mystical and religious nature of the deeply personal. A natural harmony arises that is optimistic and heartening and that dwells on the small things that are valuable beyond their size. Much of the nature of Ms. Norton's deeply human writings is captured in a brief, poignant moment in *Merlin's Mirror*. Myrddin, the alien child, alone and without allies, must again go forth into a world that barely tolerates him and that certainly doesn't understand him. He must fulfill an immense responsibility that he didn't ask for, barely understands, and often dislikes. As he leaves his camp, he turns and addresses the only friend he has made in his wanderings:

> "Little brother," he said. and at his words the raven stopped its fierce tearing of the meat, looking up at him with beads of eyes which seemed more knowing than any Myrddin had ever seen set in a bird skull. "Farewell, keep safe. When I return you shall feast again" (A115, p. 91).

Indiana, 1980

PART A
FICTION

1934

A01 *The Prince Commands, Being Sundry Adventures of Michael Karl,
sometime Crown Prince & Pretender to the Throne of Morvania.*
New York: D. Appleton-Century.

1938

A02 *Ralestone Luck.* New York: D. Appleton-Century.

1942

A03 *Follow the Drum, Being the Ventures and Misadventures of one
Johanna Lovell, Sometime Lady of Catkept Manor in Kent County
of Lord Baltimore's Proprietary of Maryland, in the Gracious Reign
of King Charles the Second.* New York: Wm. Penn.

1944

A04 *The Sword is Drawn.* Cambridge, MA: Houghton Mifflin.

1947

A05 "The People of the Crater" [Andrew North, pseud.]. *Fantasy
Book*, 1, No. 1, pp. 4-18.

Donald A. Wollheim, ed. *Swordsmen in the Sky*. New York: Ace
Books, 1964 [paper], as "People of the Crater."

Roger Elwood and Sam Moskowitz, eds. *Alien Earth and Other
Stories*. [New York]: Macfadden-Bartell, 1969 [paper].

In *Garan the Eternal*, 1972 (A94), as "Garin of Tav."

A06 *Rogue Reynard, Being a tale of the Fortunes and Misfortunes and
divers Misdeeds of that great Villain, Baron Reynard, the Fox, and
how he was served with King Lion's Justice. Based upon The Beast
Saga.* Boston: Houghton Mifflin.

1

1948

A07 "The Gifts of Asti" [Andrew North, pseud.]. *Fantasy Book*, 1, No. 3, pp. 8-17.

Basil Wells and Andrew North [pseud.], eds. *Griffin Booklet One.* Los Angeles: Griffin Publishing, 1949 [paper]. Bound with "Empire of Dust" by Basil Wells.

Sam Moskowitz and Roger Elwood, eds. *The Time Curve.* [New York]: Tower, 1968 [paper].

In *The Many Worlds of Andre Norton*, 1974 (A109).

Roger Elwood, ed. *The Gifts of Asti and Other Stories of Science Fiction.* Chicago: Follett Publishing, 1975. [Note: Last page of story missing.]

Jane Mobley, ed. *Phantasmagoria: Tales of Fantasy and the Supernatural.* Garden City, NY: Anchor Books, 1977 [paper].

Racine, WI: Educational Progress/division of Educational Development Corporation-Western Publishing, [1979?] [paper]. Issued as a separate work in an abridged edition [edited by Roger Elwood?].

A08 *Scarface, Being the Story of one Justin Blade, late of the Pirate Isle of Tortuga, and how Fate did justly deal with him, to his great Profit.* New York: Harcourt, Brace.

1949

A09 *Sword in Sheath.* New York: Harcourt, Brace.

London: Staples Press, 1953, as *Island of the Lost* (A14).

1951

A10 *Bullard of the Space Patrol* [edited collection]. Cleveland: World Publishing. By Malcolm Jameson.

A11 *Huon of the Horn, Being a Tale of that Duke of Bordeaux Who Came to Sorrow at the Hands of Charlemagne and Yet Won the Favor of Oberon, the Elf King, to his Lasting Fame and Great Glory.* New York: Harcourt, Brace.

1952

A12 *Star Man's Son 2250 A.D.* New York: Harcourt, Brace.

New York: Ace Books, [1954] [paper] as *Daybreak æ2250 A.D.* (A18) Bound with *Beyond Earth's Gates* by Lewis Padgett and C. L. Moore.

New York: Fawcett Crest, [1978] [paper] as *Star Man's Son.*

1953

A13 "All Cats Are Gray" [Andrew North, pseud.]. *Fantastic Universe,* 1 (August-September), pp. 129-134.

Ben Bova, ed. *The Many Worlds of Science Fiction.* New York: E. P. Dutton, 1971.

Jane Yolen, ed. *Zoo 2000: Twelve Stories of Science Fiction and Fantasy Beasts.* New York: Seabury Press, 1973.

In *The Many Worlds of Andre Norton,* 1974 (A109).

Isaac Asimov, Martin H. Greenberg, and Charles G. Waugh, eds. *Science Fiction A to Z,* Boston: Houghton Mifflin, 1982.

Martin H. Greenberg, Charles G. Waugh, and Jenny-Lynn Waugh, eds. *101 Science Fiction Stories,* New York: Avenel Books, 1986.

In *Wizards' Worlds,* 1989 (A183).

A14 *Island of the Lost.* See *Sword in Sheath,* 1949 (A09).

A15 *Space Service* [anthology]. Cleveland: World Publishing.

A16 *Star Rangers.* New York: Harcourt, Brace.

New York: Ace Books, 1955 [paper], as *The Last Planet* (A23). Bound with *A Man Obsessed* by Alan E. Nourse.

1954

A17 *At Swords' Points.* New York: Harcourt, Brace.

A18 *Daybreak —2250 A.D.* See *Star Man's Son 2250 A.D.*, 1952 (A12).

A19 "Mousetrap." *The Magazine of Fantasy and Science Fiction*, 6 (June), pp. 47-52.

 T. E. Dikty, ed. *The Best Science-Fiction Stories and Novels. 1955.* New York: Frederick Fell, 1955.

 In *The Many Worlds of Andre Norton*, 1974 (A109).

 Annette Peltz McComas, ed. *The Eureka Years*, New York: Bantam Books, 1982.

 In *Wizards' Worlds*, 1989 (A183).

A20 *Murders for Sale* [Allen Weston, pseud.]. London: Hammond, Hammond. With Grace Allen Hogarth.

 New York: Tom Doherty Associates, 1991, as *Sneeze on Sunday* (A194). With Grace Allen Hogarth. [Note: copyright date printed as 1992.]

A21 *Space Pioneers* [anthology]. New York: World Publishing.

A22 *The Stars Are Ours!* Cleveland: World Publishing.

1955

A23 *The Last Planet.* See *Star Rangers*, 1953 (A16).

A24 *Sargasso of Space: A Dane Thorson —Solar Queen Adventure* [Andrew North, pseud.]. New York: Gnome Press.

A25 *Star Guard.* New York: Harcourt, Brace.

A26 *Yankee Privateer.* Cleveland: World Publishing.

1956

A27 *The Crossroads of Time*. New York: Ace Books [paper]. Bound with *Mankind on the Run* by Gordon R. Dickson.

 London: Gollancz, 1976.

A28 *Plague Ship: A Dane Thorson —Solar Queen Adventure* [Andrew North, pseud.]. New York: Gnome Press.

 New York: Ace, 1959 [paper]. Bound with *Voodoo Planet* (A39).

A29 *Space Police* [anthology]. Cleveland: World Publishing.

A30 *Stand to Horse*. New York: Harcourt, Brace.

1957

A31 *Sea Siege*. New York: Harcourt, Brace.

 New York: Ace, 1962 [paper]. Bound with *Eye of the Monster* (A47).

A32 *Star Born*. Cleveland: World Publishing.

1958

A33 "By a Hair." *Phantom Magazine* [Britain], 1 (July), pp. 32-40.

 In *High Sorcery*, 1970 (A80).

 In *Wizards' Worlds*, 1989 (A183).

A34 *Star Gate*. New York: Harcourt, Brace.

 New York: Ace Books, [1963] [paper]. [Prologue added by the author.]

A35 *The Time Traders*. Cleveland: World Publishing.

1959

A36 *The Beast Master.* New York: Harcourt, Brace.

 New York: Ace Books, 1961 [paper] [abr. ed.]. Bound with *Star Hunter* (A45).

A37 *Galactic Derelict.* Cleveland: World Publishing.

A38 *Secret of the Lost Race.* New York: Ace Books [paper]. Bound with *One Against Herculum* by Jerry Sohl.

 London: Robert Hale, 1977, as *Wolfshead* (A131).

A39 *Voodoo Planet* [Andrew North, pseud.]. New York: Ace Books [paper]. Bound with *Plague Ship* [Andrew North, pseud.], 1956 (A28).

 New York: Ace, 1968 [paper]. Bound with *Star Hunter* (A45).

 New York: Ace, 1971 [paper]. Bound alone [unconfirmed].

 Boston: Gregg Press, 1978. Bound with *Star Hunter* (A45).

1960

A40 *Shadow Hawk.* New York: Harcourt, Brace.

A41 *The Sioux Spaceman.* New York: Ace Books [paper]. Bound with *And Then the Town Took Off* by Richard Wilson.

 London: Hale, 1976 [unconfirmed].

A42 *Storm Over Warlock.* Cleveland: World Publishing.

1961

A43 *Catseye.* New York: Harcourt, Brace & World.

A44 *Ride Proud, Rebel!* Cleveland: World Publishing.

A45 *Star Hunter.* New York: Ace Books [paper]. Bound with *The Beast Master*, (A36).

 Boston: Gregg Press, 1978. Bound with *Voodoo Planet* (A39).

1962

A46 *The Defiant Agents.* Cleveland: World Publishing.

A47 *Eye of the Monster.* New York: Ace Books [paper]. Bound with *Sea Siege*, 1957 (A31).

 New York: Ace, 1975 [paper]. Bound alone.

A48 *Lord of Thunder.* New York: Harcourt, Brace & World.

A49 *Rebel Spurs.* Cleveland: World Publishing.

1963

A50 *Judgment on Janus.* New York: Harcourt, Brace & World.

A51 *Key Out of Time.* Cleveland: World Publishing.

A52 *Witch World.* New York: Ace Books [paper].

 Boston: Gregg Press, 1977.

 In *Annals of the Witch World*, 1994 (A208).

1964

A53 *Night of Masks.* New York: Harcourt, Brace & World.

A54 *Ordeal in Otherwhere.* Cleveland: World Publishing.

A55 *Web of the Witch World.* New York: Ace Books [paper].

 Boston: Gregg Press, 1977.

 In *Annals of the Witch World*, 1994 (A208)

1965

A56 *Quest Crosstime.* New York: Viking Press.

 London: Victor Gollancz, 1975, as *Crosstime Agent* (A112).

A57 *Steel Magic*. Cleveland: World Publishing.

New York: Scholastic Book Services, 1967, as *Gray Magic* (A65). [paper].

In *The Magic Books*, 1988 (A175) [paper].

A58 *Three Against the Witch World*:[:Beyond the Mind Barrier]. New York: Ace Books [paper].

Boston: Gregg Press, 1977.

A59 *The X Factor*. New York: Harcourt, Brace & World.

A60 *Year of the Unicorn*. New York: Ace Books [paper].

Boston: Gregg Press, 1977.

In *Annals of the Witch World*, 1994 (A208).

1966

A61 "The Boy and the Ogre," *Golden Magazine for Boys and Girls*, 3 (September), pp. 45-48.

A62 *Moon of Three Rings*. New York: Viking Press.

A63 "The Toymaker's Snuffbox," *Golden Magazine for Boys and Girls*, 3 (August), pp. 2-8.

In *Moon Mirror*, 1988 (A176).

A64 *Victory on Janus*. New York: Harcourt, Brace & World.

1967

A65 *Gray Magic*. See *Steel Magic*, 1965 (A57).

A66 *Octagon Magic*. Cleveland: World Publishing.

In *The Magic Books*, 1988 (A175) [paper].

A67 *Operation Time Search.* New York: Harcourt, Brace & World.

A68 *Warlock of the Witch World.* New York: Ace Books [paper].

 Boston: Gregg Press, 1977.

A69 "Wizard's World." *Worlds of If,* 17 (June), pp. 7-49.

 In *High Sorcery,* 1970 (A80).

 Isaac Asimov, Martin H. Greenberg, and Charles G. Waugh, eds.
 Isaac Asimov's Magical Worlds of Fantasy 2 : Witches, New York:
 Signet, 1984 [paper].

 Isaac Asimov, Martin H. Greenberg, and Charles G. Waugh, eds.
 Isaac Asimov's Magical Worlds of Fantasy :Wizards & Witches , New
 York: Bonanza, 1984.

 In *Wizards' Worlds,* 1989 (A183) as "Wizards' Worlds."

1968

A70 *Dark Piper.* New York: Harcourt, Brace & World.

A71 *Fur Magic.* Cleveland: World Publishing.

 Donald A. Wollheim, ed. *The DAW Science Fiction Reader.* New
 York: DAW Books, 1976 [paper].

 In *The Magic Books,* 1988 (A175) [paper].

 With Alicia Austin, ill., Hampton Falls, NH: Donald M. Grant,
 1993.

A72 *Sorceress of the Witch World.* New York: Ace Books [paper].

 Boston: Gregg Press, 1977.

A73 *The Zero Stone.* New York: Viking Press.

1969

A74 *Bertie and May.* New York: World Publishing. With Bertha
 Stemm Norton.

A75 "Garan of Yu-Lac." *Spaceway Science Fiction*, 4, Part One
 (September-October), pp. 38-55; 5, Part Two (May-June, 1970),
 pp. 63-88 [Part Three never published; the first complete version
 is cited below]:

 In *Garan the Eternal*, 1972 (A93).

A76 *Postmarked the Stars.* New York: Harcourt, Brace & World.

A77 "Toys of Tamisan." *Worlds of If*, 19, Part One (April), pp. 5-44;
 Part Two (May), pp. 107-145.

 In *High Sorcery*, 1970 (A80).

 Included as part of the novel *Perilous Dreams*, 1976 (A120).

 In *Wizards' Worlds*, 1989 (A183).

A78 *Uncharted Stars.* New York: Viking Press.

1970

A79 *Dread Companion.* New York: Harcourt Brace Jovanovich.

A80 *High Sorcery.* New York: Ace Books [paper] ["By a Hair," 1958;
 "Wizard's World," 1967; "Toys of Tamisan," 1969; "Through
 the Needle's Eye," "Ully the Piper"].

A81 *Ice Crown.* New York: Viking Press.

A82 "Long Live Lord Kor!" *Worlds of Fantasy*, 1, No. 2, pp. 50-
 72,148-192.

 In *The Many Worlds of Andre Norton*, 1974 (A109).

A83 "Through the Needle's Eye." In *High Sorcery*, 1970 (A80).

 Seon Manley and Gogo Lewis, eds. *Sisters of Sorcery: Two*

Centuries of Witchcraft Stories by the Gentle Sex. New York: Lothrop, Lee & Shepard, 1976.

In *Moon Mirror*, 1988 (A176).

A84 "Ully the Piper." In *High Sorcery*, 1970 (A80).

Diana Wynne Jones, ed. *Fantasy Stories.* New York: Kingfisher, 1994 [paper].

1971

A85 *Android at Arms.* New York: Harcourt Brace Jovanovich.

A86 *Exiles of the Stars.* New York: Viking Press.

1972

A87 "Amber Out of Quayth." In *Spell of the Witch World*, 1972 (A97).

A88 *Breed to Come.* New York: Viking Press.

A89 *The Crystal Gryphon.* New York: Atheneum.

A90 *Dragon Magic.* New York: Thomas Y. Crowell.

Excerpt as "Artos, Son of Marius." In *The Pendragon Chronicles,* ed. Mike Ashley, New York: Peter Bedrick Books, 1990.

A91 "Dragon Scale Silver." In *Spell of the Witch World*, 1972 (A97).

A92 "Dream Smith." In *Spell of the Witch World*, 1972 (A97).

A93 *Garan the Eternal.* Alhambra, CA: Fantasy Publishing ["People of the Crater," 1947, as "Garin of Tav"; "Garan of Yu-Lac," 1969; "Legacy from Sorn Fen"; "One Spell Wizard"].

A94 "Garan of Tav." See "People of the Crater" (A05).

A95 "Legacy from Sorn Fen." In *Garan the Eternal*, 1972 (A93).

In *Lore of the Witch World*, 1980 (A143).

A96 "One Spell Wizard." In *Garan the Eternal*, 1972 (A93).

Racine, WI: Educational Progress/division of Educational
Development Corporation-Western Publishing, [1979?] [paper].
Issued as a separate work. [edited by Roger Elwood?].

In *Moon Mirror*, 1988 (A176).

A97 *Spell of the Witch World.* New York: DAW Books [paper]
["Amber Out of Quayth," "Dragon Scale Silver," "Dream
Smith"].

Boston: Gregg Press, 1977.

1973

A98 "Desirable Lakeside Residence." *Saving Worlds: A Collection of
Original Science Fiction Stories.* Eds. Roger Elwood and Virginia
Kidd. Garden City, NY: Doubleday.

Toronto, New York, and London: Bantam Books, 1974 [paper];
anthology reprinted as *The Wounded Planet.*

Racine, WI: Educational Progress/division of Educational
Development Corporation-Western Publishing, [1979?] [paper].
Issued as a separate work. [edited by Roger Elwood?].

In *Moon Mirror*, 1988 (A176).

Rick Wilber & Richard Mathews, eds. *Subtropical Speculations,*
Sarasota, FL: Pineapple Press, 1991 [paper].

A99 *Forerunner Foray.* New York: Viking Press.

A100 *Gates to Tomorrow: An Introduction to Science Fiction* [anthology].
New York: Atheneum. With Ernestine Donaldy.

A101 *Here Abide Monsters.* New York: Atheneum.

A102 "London Bridge." *The Magazine of Fantasy and Science Fiction,*
45 (October), pp. 103-114.

In *The Many Worlds of Andre Norton,* 1974 (A109).

A103 "Teddi." *Science Fiction Adventures from Way Out.* ed. Roger
 Elwood. Racine, WI: Western Publishing.

 Racine, WI: Educational Progress/division of Educational
 Development Corporation-Western Publishing, [1979?] [paper].
 Issued as a separate work. [edited by Roger Elwood?].

 In *Moon Mirror*, 1988 (A176).

 Isaac Asimov, Martin H. Greenberg, and Charles G. Waugh, eds.
 Young Star Travelers, New York: Harper & Row, 1986.

 Howard Zimmerman, Seymour Reit, and Barbara Brenner, eds.
 Bank Street Book of Science Fiction, New York: Pocket Books,
 1989 [paper]. Story adapted by Dwight John Zimmerman. Ill.
 Alex Nino and Bruce Solotoff.

A104 "Toads of Grimmerdale." *Flashing Swords! #2.* Ed. Lin Carter.
 Garden City, NY: Nelson Doubleday [Science Fiction Book
 Club].

 [New York]: Dell Books, 1974 [paper].

 In *The Many Worlds of Andre Norton*, 1974 (A109), as "The
 Toads of Grimmerdale."

 In *Lore of the Witch World*, 1980 (A143), as "The Toads of
 Grimmerdale."

 Isaac Asimov, Martin H. Greenberg, and Charles G. Waugh, eds.
 Isaac Asimov's Magical Worlds of Fantasy 4: Spells, New York:
 Signet, 1985 [paper].

 Robert Adams, Martin H. Greenberg, and Pamela Crippen
 Adams, eds. *Barbarians II*, New York: Signet, 1988 [paper].

 In *Wizards' Worlds*, 1989 (A183).

 In *Grand Masters' Choice*, 1989 (A180).

1974

A105 *Iron Cage.* New York: Viking Press.

A106 *The Jargoon Pard.* New York: Atheneum.

A107 *Lavender-Green Magic.* New York: Thomas Y. Crowell.

A108 "Long Night of Waiting." *Long Night of Waiting by Andre Norton and Other Stories.* Ed. Roger Elwood. Nashville: Aurora Publishers.

 In *The Many Worlds of Andre Norton,* 1974 (A109), as "The Long Night of Waiting."

 Racine, WI: Educational Progress/division of Educational Development Corporation-Western Publishing, [1979?] [paper]. Published as a separate work in an abridged edition [edited by Roger Elwood?].

 In *Moon Mirror,* 1988 (A176), as "The Long Night of Waiting."

 Isaac Asimov, Martin H. Greenberg, and Charles G. Waugh, eds. *Isaac Asimov's Magical Worlds of Fantasy: Faeries,* New York: Roc, 1991 [paper].

A109 *The Many Worlds of Andre Norton.* ed. Roger Elwood. Radnor, PA: Chilton ["The Gifts of Asti," 1948; "All Cats Are Gray," 1953; "Mousetrap," 1954; "Long Live Lord Kor!" 1970; "On Writing Fantasy," 1971 (non-fiction); "London Bridge," "Toads of Grimmerdale," 1973 "The Long Night of Waiting," "Norton Bibliography" (non-fiction);].

 New York: DAW Books, [1975] [paper], as *The Book of Andre Norton.* [without "Norton Bibliography.]

A110 *Outside.* New York: Walker.

A111 *Small Shadows Creep* [anthology]. New York: E. P. Dutton.

1975

A112 *Crosstime Agent.* See *Quest Crosstime,* 1965 (A56).

A113 *The Day of the Ness.* New York: Walker. With Michael Gilbert.

A114 *Knave of Dreams.* New York: Viking Press.

A115 *Merlin's Mirror*. New York: DAW Books [paper].

London: Sidgwick & Jackson, 1976.

A116 *No Night Without Stars*. New York: Atheneum.

A117 *Star Ka'at*. New York: Walker. With Dorothy Madlee. [Note:
 copyright date printed as 1976.]

A118 *The White Jade Fox*. New York: E. P. Dutton.

1976

A119 *Baleful Beasts and Eerie Creatures* [anthology]. Chicago: Rand
 McNally.

A120 *Perilous Dreams*. New York: DAW Books [paper]. ["Toys of
 Tamisan," 1969, is included as the first chapter.]

A121 *Red Hart Magic*. [New York]: Thomas Y. Crowell.

A122 "Spider Silk." *Flashing Swords! #3: Warriors and Wizards*. ed. Lin
 Carter. [New York]: Dell Books [paper].

 In *Lore of the Witch World*, 1980 (A143).

 Isaac Asimov, Martin H. Greenberg, and Charles G. Waugh, eds.
 Baker's Dozen: 13 Short Fantasy Novels, New York: Greenwich
 House, 1984.

 Isaac Asimov, Martin H. Greenberg, and Charles G. Waugh, eds.
 The Mammoth Book of Short Fantasy Novels, London: Robinson,
 1986 [paper]. [unverified]

 In *Wizards' Worlds*, 1989 (A183).

A123 *Wraiths of Time*. New York: Atheneum.

1977

A124 *The Opal-Eyed Fan*. New York: E. P. Dutton.

A125 "Sword of Ice." In *Trey of Swords*, 1977 (A129).

A126 "Sword of Lost Battles." In *Trey of Swords*, 1977 (A129).

A127 "Sword of Shadow." In *Trey of Swords*, 1977 (A129).

A128 "Sword of Unbelief." *Swords Against Darkness II*. ed. Andrew J. Offutt. [New York]: Zebra Books [paper].

 In *Lore of the Witch World*, 1980 (A143).

 In *Wizards' Worlds*, 1989 (A183).

A129 *Trey of Swords*. New York: Grosset & Dunlap ["Sword of Ice," "Sword of Lost Battles," and "Sword of Shadow"].

A130 *Velvet Shadows*. Greenwich, CT: Fawcett Publications [paper].

A131 *Wolfshead*. See *Secret of the Lost Race*, 1959 (A38).

1978

A132 *Quag Keep*. New York: Atheneum.

 Pre-book-publication excerpt in *The Dragon: The Magazine of Fantasy, Swords & Sorcery and Science Fiction Gaming*, II, No. 6 (February), pp. 22-30.

A133 *Star Ka'at World*. New York: Walker. With Dorothy Madlee.

A134 *Yurth Burden*. New York: DAW Books [paper].

A135 *Zarsthor's Bane*. New York: Ace Books [paper].

1979

A136 "Falcon Blood." *Amazons!* Ed. Jessica Amanda Salmonson. New York: DAW [paper].

 In *Lore of the Witch World*, 1980 (A143).

 In *Wizards' Worlds*, 1989 (A183).

A137 "Sand Sister." *Heroic Fantasy*. Eds. Gerald W. Page and Hank
 Reinhardt. New York: DAW Books [paper].

 In *Lore of the Witch World*, 1980 (A143).

 Robert Adams, Martin H. Greenberg, and Charles G. Waugh,
 eds. *Barbarians*, New York: Signet, 1986 [paper].

 In *Wizards' Worlds*, 1989 (A183).

A138 *Seven Spells to Sunday*. New York: Atheneum. With Phyllis
 Miller.

A139 *Snow Shadow*. New York: Fawcett Crest [paper].

A140 *Star Ka'ats and the Plant People*. New York: Walker. With
 Dorothy Madlee.

1980

A141 "Changeling." In *Lore of the Witch World*, 1980 (A143).

 In *Wizards' Worlds*, 1989 (A183).

A142 *Iron Butterflies*. New York: Fawcett Crest [paper].

A143 *Lore of the Witch World*. New York: DAW [paper]. Collection.
 ["Legacy from Sorn Fen," 1972; "The Toads of Grimmerdale,"
 1973; "Spider Silk," 1976; "Sword of Unbelief," 1977; "Falcon
 Blood," "Sand Sister," 1979; "Changeling," 1980].

 All but "Legacy from Sorn Fen" reprinted in *Wizards' Worlds*
 (A183).

A144 *Voorloper*. Ill. Alicia Austin. New York: Ace [paper].

 Garden City, NY: Science Fiction Book Club, 1980.

1981

A145 *Forerunner.* New York: Tom Doherty Associates [paper].

Garden City, NY: Science Fiction Book Club, 1981.

A146 *Gryphon in Glory.* New York: Atheneum.

A147 *Horn Crown.* New York: DAW [paper].

Garden City, NY: Science Fiction Book Club, 1981.

A148 *Maid-at-Arms.* Fawcett Coventry Romance [paper]. By Enid Cushing. [Andre Norton prepared this book for publishing.]

A149 *Star Ka'ats and the Winged Warriors.* New York: Walker. With Dorothy Madlee.

A150 *Ten Mile Treasure.* New York: Pocket/Archway [paper].

1982

A151 *Moon Called.* New York: Simon & Schuster/Wallaby Books [paper].

A152 "Moon Mirror." *Hecate's Cauldron.* Ed. Susan Shwartz. New York: DAW [paper]. pp. 62-75.

[no editor given] *A Southern Fantasy: Thirteenth World Fantasy Convention,* Nashville: Nashville World Fantasy Committee, 1987 [paper], pp. 43-48.

In *Moon Mirror,* 1988 (A176).

1983

A153 *Caroline.* New York: Tom Doherty Associates [paper]. With Enid Cushing.

A154 *'Ware Hawk.* New York: Atheneum/Argo.

A155 *Wheel of Stars.* New York: Wallaby [paper].

1984

A156 *Gryphon's Eyrie*. New York: Tom Doherty Associates. With A[nn] C. Crispin.

A157 *House of Shadows*. New York: Atheneum. With Phyllis Miller.

A158 *Stand and Deliver*. New York: Dell [paper].

A159 *Were-Wrath*. New Castle, VA: Cheap Street.

 In *Wizards' Worlds*, 1989 (A183).

1985

A160 *Forerunner: The Second Venture*. New York: Tom Doherty Associates.

A161 *Magic In Ithkar* [anthology]. New York: Tom Doherty Associates [paper]. With Robert Adams ["Swamp Dweller," 1985].

A162 *Magic In Ithkar 2* [anthology]. New York: Tom Doherty Associates [paper]. With Robert Adams.

A163 *Ride the Green Dragon*. New York: Atheneum. With Phyllis Miller.

A164 "Swamp Dweller." In *Magic In Ithkar*, 1985 (A161).

 In *Wizards' Worlds*, 1989 (A183).

1986

A165 *Flight in Yiktor*, New York: Tom Doherty Associates.

A166 *Magic In Ithkar 3* [anthology]. New York: Tom Doherty Associates [paper]. With Robert Adams.

1987

A167 *The Gate of the Cat*. New York: Ace.

A168 *Magic In Ithkar 4* [anthology]. New York: Tom Doherty Associates [paper]. With Robert Adams.

A169 "Of the Shaping of Ulm's Heir." In *Tales of the Witch World*, 1987 (A172).

A170 "Rider on a Mountain." *Friends of the Horseclans*. Ed. Robert Adams. New York: Tom Doherty Associates [paper].

A171 *Serpent's Tooth*. Winter Park, FL: Andre Norton Ltd. [paper].

A172 *Tales of the Witch World* [anthology]. New York: Tom Doherty Associates ["Of the Shaping of Ulm's Heir," 1987].

1988

A173 "The Dowry of the Rag Picker's Daughter." *Arabesques: More Tales of the Arabian Nights*. Ed. Susan Shwartz. New York: Avon [paper].

A174 "How Many Miles to Babylon?" In *Moon Mirror*, 1988 (A176).

A175 *The Magic Books,* New York: Signet [paper]. Collects *Fur Magic* (A71), *Steel Magic* (A57), *Octagon Magic* (A66).

A176 *Moon Mirror.* ed. Ingrid Zierhut, New York: Tom Doherty Associates ["The Toymaker's Snuffbox," 1966; "Through the Needle's Eye," 1970; "One Spell Wizard," 1972; "Desirable Lakeside Residence," "Teddi," 1973; "The Long Night of Waiting," "Outside," 1974; "Moon Mirror," 1982; "How Many Miles to Babylon?" 1988].

A177 *Tales of the Witch World 2* [anthology]. New York: Tom Doherty Associates

1989

A178 *Catfantastic* [anthology]. New York: DAW [paper]. With Martin H. Greenberg ["Noble Warrior," "Speaking of Cats—" (nonfiction) 1989].

A179 *Four from the Witch World* [anthology]. New York: Tom Doherty Associates.

A180 *Grand Masters' Choice* [anthology]. Cambridge MA: NESFA Press. With Ingrid Zierhut ["Toads of Grimmerdale," 1973].

A181 *Imperial Lady: A Fantasy of Han China*, New York: Tom Doherty Associates. With Susan Shwartz ["Historical Note" (non-fiction)].

A182 "Noble Warrior." In *Catfantastic*, 1989 (A178).

A183 *Wizards' Worlds*. ed. Ingried [sic, Ingrid] Zierhut, New York: Tom Doherty Associates ["All Cats Are Gray," 1953; "Mousetrap," 1954; "By a Hair," 1958; "Wizard's Worlds," 1967; "Toys of Tamisan," 1969; "Toads of Grimmerdale," 1973; "Spider Silk," 1976; "Sword of Unbelief," 1977; "Falcon Blood," "Sand Sister," 1979; "Changeling," 1980; "Were-Wrath," 1984; "Swamp Dweller," 1985]. [Note: Ingrid Zierhut's name is spelled incorrectly.]

1990

A184 *Black Trillium*. New York: Doubleday. With Marion Zimmer Bradley and Julian May.

A185 *Dare to Go A-Hunting*. New York: Tom Doherty Associates.

A186 *The Jekyll Legacy*. New York: Tom Doherty Associates. With Robert Bloch.

A187 *Tales of the Witch World 3* [anthology]. New York: Tom Doherty Associates.

1991

A188 *Catfantastic II* [anthology]. New York: DAW [paper]. With Martin H. Greenberg ["Hob's Pot," 1991].

A189 "The Chronicler: 'There was a time...'" In *Storms of Victory*, 1991 (A195).

A190 *The Elvenbane.* New York: Tom Doherty Associates. With Mercedes Lackey.

A191 "Hob's Pot." In *Catfantastic II*, 1991 (A188).

A192 "Port of Dead Ships." In *Storms of Victory*, 1991 (A195).

A193 "The Silent One," *Pulphouse : A Weekly Magazine*, 1.1 (June 1), pp. 15-22.

 Robert Garcia, ed. *Chilled to the Bone*, Niles, IL: Mayfair Games, 1991 [paper].

A194 *Sneeze on Sunday.* See *Murders for Sale*, 1954 (A20).

A195 *Storms of Victory: Witch World: The Turning.* New York: Tom Doherty Associates. With P. M. Griffin ["Port of Dead Ships," "The Chronicler: 'There was a time...'," 1991].

1992

A196 "The Chronicler: 'Once I was Duratan...'" In *Flight of Vengeance*, 1992 (A197).

A197 *Flight of Vengeance: Witch World: The Turning, Book 2.* New York: Tom Doherty Associates. With P. M. Griffin and Mary H. Schaub.
 ["The Chronicler: 'Once I was Duratan...'"].

A198 *The Mark of the Cat.* New York: Ace.

A199 "The Nabob's Gift." *All Hallow's Eve.* ed. Mary Elizabeth Allen. New York: Walker.

A200 "Nine Threads of Gold." *After the King.* eds. Martin H. Greenberg and Jane Yolen. New York: Tom Doherty Associates.

A201 *Songsmith.* New York: Tom Doherty Associates. With A[nn] C. Crispin

A202 "That Which Overfloweth." *Grails: Quests, Visitations and Other Occurrences.* eds. Richard Gilliam, Martin H. Greenberg and Edward E. Kramer. Atlanta, GA: Unnameable Press.

Grails: Quests of the Dawn. eds. Richard Gilliam, Martin H. Greenberg and Edward E. Kramer. New York: Roc, 1994 [paper].

A203 "A Very Dickensy Christmas." *The Magic of Christmas.* Eds. John Silbersack and Chris Schelling. New York: Roc, 1994 [paper].

1993

A204 *Brother to Shadows.* New York: AvoNova.

A205 *Empire of the Eagle.* New York: Tom Doherty Associates. With Susan Shwartz.

A206 *Golden Trillium.* New York: Bantam.

A207 *Redline the Stars.* New York: Tom Doherty Associates. With P. M. Griffin.

1994

A208 *Annals of the Witch World.* [Garden City]: Science Fiction Book Club. Collects *Witch World* (A52), *Web of the Witch World* (A55) and *Year of the Unicorn* (A60).

A209 *Catfantastic III* [anthology]. New York: DAW [paper]. With Martin H. Greenberg ["Noble Warrior Meets with a Ghost"].

A210 "The Chronicler: 'There are places in this ancient land...'" In *On Wings of Magic*, 1994 (A214).

A211 *Firehand.* New York: Tom Doherty Associates. With P. M. Griffin.

A212 *The Hands of Lyr.* New York: AvoNova.

A213 "Noble Warrior Meets with a Ghost." In *Catfantastic III*, 1994 (A209).

A214 *On Wings of Magic: Witch World: The Turning, Book 3.* New York: Tom Doherty Associates. With Patricia Mathews and Sasha Miller ["The Chronicler: 'There are places in this ancient land...,'" 1994].

PART B
MISCELLANEOUS MEDIA

1943

B01 "Freedom" [poem]. *Cleveland Press*, September [from Andre Norton's personal files: date and newspaper title handwritten. Unverified].

1976

B02 "Cats" [poem]. *Omniumgathum: An Anthology of Verse by Top Authors in the Field of Fantasy*. Ed. Jonathon Bacon and Steve Troyanovich. Lamoni, IA: Stygian Isle Press [paper].

 Mon-Con I [Bulletin]. Morgantown, WV: Monogamoot Science Fiction Society, [n.d.] [paper].

B03 "The Last Cohort" [poem]. *Omniumgathum: An Anthology of Verse by Top Authors in the Field of Fantasy*. Ed. Jonathon Bacon and Steve Troyanovich. Lamoni, IA: Stygian Isle Press [paper].

B04 "Song of the Barbarian Swordsman" [poem]. *Omniumgathum: An Anthology of Verse by Top Authors in the Field of Fantasy*. Ed Jonathon Bacon and Steve Troyanovich. Lamoni, IA: Stygian Isle Press [paper].

PART C
NONFICTION

1936

C01 "Ah, for Good Old Days of the Horsecar Age!" [writing as A.N.]. *The Cleveland Plain Dealer*, 20 September, Women's Magazine and Amusement Section, p. 15. Review of *Young Ladies Should Marry* by Jessie Benton Freemont and Elizabeth Henry Redfield.

C02 "A British Navy Officer's Adventures in Red Russia" [writing as A.N.]. *The Cleveland Plain Dealer*, 8 November, Women's Magazine and Amusement Section, p. 15. Review of *Interval Ashore* by Horton Giddy.

C03 "Bronte [sic] Sisters Lively Heroines of Vivid Novel" [writing as A.N.]. *The Cleveland Plain Dealer*, 8 November, Magazine and Amusement Section, p. 15. Review of *Divide the Desolation* by Kathryn Jean MacFarlane.

C04 "Father's Tyranny Brings Unhappiness to Children" [writing as A.N.]. *The Cleveland Plain Dealer*, 12 July, Women's Magazine and Amusement Section, p. 13. Review of *Strange Harvest* by Mildred Burcham Hart.

C05 "Garden, Kitchen, Camp: Wilderness Asylum" [writing as A.N.]. *The Cleveland Plain Dealer*, 29 November, Women's Magazine and Amusement Section, p. 15. Review of *Mansions in the Cascades* by Anne Shannon Monroe and Elizabeth Lambert Wood.

C06 "Girl's Wedding Offers No Escape for Mother" [writing as A.N.]. *The Cleveland Plain Dealer*, 28 June, Women's Magazine and Amusement Section, p. 15. Review of *Mother of the Bride* by Alice Grant Rosman.

C07 "Gloria Vanderbilt Tells Her Side of Famous Case" [writing as A.N.]. *The Cleveland Plain Dealer*, 20 December, Women's Magazine and Amusement Section, p. 15. Review of *Without Prejudice* by Gloria Morgan Vanderbilt.

C08 "Jealous Family Schemes to Fleece Rich 'Black Sheep'" [writing as A.N.]. *The Cleveland Plain Dealer*, 26 July, Women's Magazine and Amusement Section, p. 15. Review of *Friendly Relations* by Audrey Lucas.

C09 "Moving Day Alters Course of Five Lives in Family" [writing as A.N.]. *The Cleveland Plain Dealer*, 11 October, Women's Magazine and Amusement Section, p. 19. Review of *The New House* by Lettice Cooper.

C10 "Old Pledge Brings Staid Hero Out of Retirement" [writing as A.N.]. *The Cleveland Plain Dealer*, 9 August, Women's Magazine and Amusement Section, p. 13. Review of *The Man from the Norlands* by John Buchan.

C11 "Retired Sleuth Solves a Murder to Clear His Name" [writing as A.N.]. *The Cleveland Plain Dealer*, 4 October, Women's Magazine and Amusement Section, p. 17. Review of *Trent's Own Case* by E. C. Bentley and H. Warner Allen.

C12 "Samplers for Girl Readers of All Ages" [writing as A.N.]. *The Cleveland Plain Dealer*, 15 November, Women's Magazine and Amusement Section, p. 15. Reviews of *Mademoiselle Misfortune* by Carol Ryrie Brink; *Raquel, A Girl of Puerto Rico* by Chesley Kahman [Mable Chesley Kahmann]; *Come Summer* by Virginia McCarty Bare; and *The Doll House at World's End* by Marjorie Knight.

C13 "She Seeks—and Finds—Beauty in City's Slums" [writing as A.N.]. *The Cleveland Plain Dealer*, 14 June, Women's Magazine and Amusement Section, p. 15. Review of *Death Is a Little Man* by Minnie Hite Moody.

C14 "Some Recent Fiction: Romance of Clipper Ships" [writing as A.N.]. *The Cleveland Plain Dealer*, 22 November, Women's Magazine and Amusement Section, p. 15. Review of *John Dawn* by Robert P. Tristram Coffin.

C15 "Some Recent Fiction: Sally Saves the Day" [writing as A.N.]. *The Cleveland Plain Dealer*, 20 December, Women's Magazine and Amusement Section, p. 15. Review of *Summer of Life* by Beatrice Kean Seymour.

C16 "Some Recent Fiction: 'The Old Order Changeth'" [writing as
 A.N.]. *The Cleveland Plain Dealer*, 20 December, Women's
 Magazine and Amusement Section, p. 15. Review of *Honorable
 Estate* by Vera Brittain.

C17 "Tale is Reminiscent of a Mild Thorne Smith Plot" [writing as
 A.N.]. *The Cleveland Plain Dealer*, 1 November, Women's
 Magazine and Amusement Section, p. 17. Review of *Hell's Bells*
 by Marmaduke Dixey.

C18 "Terry Defies Ghost and Almost Gets a Bargain" [writing as
 A.N.]. *The Cleveland Plain Dealer*, 16 August, Women's Maga-
 zine and Amusement Section, p. 15. Review of *The Crowing Hen*
 by Reginald Davis.

C19 "Trace History of Woman's Long Fight for Freedom" [writing as
 A.N.]. *The Cleveland Plain Dealer*, 20 December, Women's
 Magazine and Amusement Section, p. 15. Review of *Pamela's
 Daughters* by Robert Palfrey Utter and Gwendolyn Bridges
 Needham.

C20 "Two-Day Journey Changes Destiny of Four People" [writing as
 A.N.]. *The Cleveland Plain Dealer*, 5 July, Women's Magazine
 and Amusement Section, p. 15. Review of *Return to Coolami* by
 Eleanor Dark.

1937

C21 "Book Makes Weak Plea for Artists' Freedom" [writing as A.N.].
 The Cleveland Plain Dealer, 19 December, Women's Magazine
 and Amusement Section, p. 17-C. Review of *Sun Across the Sky*
 by Eleanor Dark.

C22 "Cathedral Town Tale Reads Like a Fantasy" [writing as A.N.].
 The Cleveland Plain Dealer, 28 February, Women's Magazine and
 Amusement Section, p. 15. Review of *A City of Bells* by Elizabeth
 Goudge. [not verifiable]

C23 "A Co-Ed of the [18]60's" [writing as A.N.]. *The Cleveland Plain
 Dealer*, 21 November, Women's Magazine and Amusement
 Section, p. 16-C. Review of *College in Crinoline* by Marjorie
 Medary.

C24 "'Dead' Men Are Avengers" [writing as A.N.]. *The Cleve-land Plain Dealer*, Women's Magazine and Amusement Section, p. 15-C. Review of *The Four Dead Men* by Spencer Simpson. [not verifiable]

C25 "Death Over Navy" [writing as A.N.]. *The Cleveland Plain Dealer*, 3 October, Women's Magazine and Amusement Section, p. 17-C. Review of *The Hush-Hush Murders* by Margaret Taylor Yates.

C26 "Delicately Spun Story Not for Robust Tastes" [writing as A.N.]. *The Cleveland Plain Dealer*, 7 March, Women's Magazine and Amusement Section, p. 17. Review of *Humming Bird* by Eleanor Farjeon.

C27 "Diaries Result in Murder" [writing as A.N.]. *The Cleveland Plain Dealer*, 31 October, Women's Magazine and Amusement Section, p. 18-C. Review of *The Moving Finger* by Cortland Fitzsimmons.

C28 "Fast Moving and Bloody" [writing as A.N.]. *The Cleveland Plain Dealer*, 27 June, Women's Magazine and Amusement Section, p. 15-C. Review of *It Wasn't a Nightmare* by L. F. Hay [Lindsay Fitzgerald Hay].

C29 "Fiction for Summer Days: A Cathedral Tragedy" [writing as A.N.]. *The Cleveland Plain Dealer*, 8 August, Women's Magazine and Amusement Section, p. 15-C. Review of *Cathedral Close* by Susan Goodyear [pseud. Margaret Matthews].

C30 "Just Too, Too Much, This Business of Coincidence" [writing as A.N.]. *The Cleveland Plain Dealer*, 14 February, Women's Magazine and Amusement Section, p. 15. Review of *Death of an Author* by E. C. R. Lorac [pseud. of Edith Caroline Rivett].

C31 "Naval Intelligence Chief Snares Killer of Skipper" [writing as A.N.]. *The Cleveland Plain Dealer*, 29 August, Women's Magazine and Amusement Section, p. 17-C. Review of *Murder of the Pigboat Skipper* by Steve Fisher.

C32 "Occupation Tale Gains Favor in Last Few Years" [writing as A.N.]. *The Cleveland Plain Dealer*, 14 November, Women's Magazine and Amusement Section, p. 22-C. Reviews of *Mid-Flight* by Edith Bishop Sherman, *Under Glass* by Nancy

Clemens, *A Home for Keeps* by Mary Virginia Provines, and *Wildcat* by William Heyliger.

C33 "Redoubtable Capt. Samson Turns to Sleuthing—Alas!" [writing as A.N.]. *The Cleveland Plain Dealer*, 17 October, Women's Magazine and Amusement Section, p. 20-C [p. 17C?]. Review of *Captain Samson, A. B.* by Gavin Douglas.

C34 "'Salted' Mines and Other Tall Tales of Engineers" [writing as A.N.]. *The Cleveland Plain Dealer*, 24 January, Women's Magazine and Amusement Section, p. 15. Review of *Pay Streak* by John Baragwanath.

C35 "Satan's Faggots Redden Gloom of Puritanic Salem" [writing as A.N.]. *The Cleveland Plain Dealer*, 18 April, Women's Magazine and Amusement Section, p. 17-C. Review of *Gallows Hill* by Frances Winwar.

C36 "Seeks Peace in Country" [writing as A.N.]. *The Cleveland Plain Dealer*, 1 August, Women's Magazine and Amusement Section, p. 15-C. Review of *Not in Our Stars* by Marguerite Mooers Marshall.

C37 "A Shelf of Recent Books for the Younger Reader: From Copy Boy to Star Reporter" [writing as A.N.]. *The Cleveland Plain Dealer*, 14 November, Women's Magazine and Amusement Section, p. 22-C. Review of *Waterfront Beat* by Howard M. Brier.

C38 "A Shelf of Recent Books for the Younger Reader: In Modern China" [writing as A.N.]. *The Cleveland Plain Dealer*, 14 November, Women's Magazine and Amusement Section, p. 22-C. Review of *Beggers of Dreams* by Mary Brewster Hollister.

C39 "A Shelf of Thrillers: Death Stalks Gay Dinner" [writing as A.N.]. *The Cleveland Plain Dealer*, 22 August, Women's Magazine and Amusement Section, p. 17-C. Review of *Murder in the Flagship* by P. Walker Taylor [Philip Walker-Taylor].

C40 "A Shelf of Thrillers: Editor Meets Violent End" [writing as A.N.]. *The Cleveland Plain Dealer*, 6 June, Women's Magazine and Amusement Section, p. 18-C. Review of *Murder in the Newspaper Guild* by Henry C. Beck.

C41 "A Shelf of Thrillers: Ghosts and Yawns" [writing as A.N.]. *The Cleveland Plain Dealer*, 8 August, Women's Magazine and Amusement Section, p. 15-C. Review of *Death's Mannikins* by Max Atford.

C42 "Some Recent Fiction: Fiend Spreads Terror" [writing as A.N.]. *The Cleveland Plain Dealer*, 20 June, Women's Magazine and Amusement Section, p. 15-C. Review of *Murder Walks the Corridors* by James D. Perry.

C43 "Some Recent Fiction: Miss Buncle Marries" [writing as A.N.]. *The Cleveland Plain Dealer*, 26 December, Women's Magazine and Amusement Section, p. 18-C. Review of *Miss Buncle Married* by D. E. Stevenson.

C44 "Some Recent Fiction: Super-Spies Debunked" [writing as A.N.]. *The Cleveland Plain Dealer*, 6 June, Women's Magazine and Amusement Section, p. 18-C. Review of *An Official Secret* by Allan Duncan.

C45 "Some Recent Fiction: Unhappy Queen" [writing as A.N.]. *The Cleveland Plain Dealer*, 25 July, Women's Magazine and Amusement Section, p. 15-C. Review of *Restoration Carnival* by Maurice Bethell Jones.

C46 "Some Recent Fiction: Wise-Cracking Mars Tale" [writing as A.N.]. *The Cleveland Plain Dealer*, 29 August, Women's Magazine and Amusement Section, p. 17-C. Review of *Buckskin Brigades* by L. Ron Hubbard.

C47 "Some Recent Fiction: Woman Breaks with Past" [writing as A.N.]. *The Cleveland Plain Dealer*, 25 July, Women's Magazine and Amusement Section, p. 15-C. Review of *Call It Freedom* by Marian Sims.

C48 "Spins Fine Tale Out of Homely Routine of Life" [writing as A.N.]. *The Cleveland Plain Dealer*, 16 May, Women's Magazine and Amusement Section, p. 18-C. Review of *August Folly* by Angela Thirkell.

C49 "Stranded Yacht Nucleus of White Jungle Realm" [writing as A.N.]. *The Cleveland Plain Dealer*, 19 September, Women's Magazine and Amusement Section, p. 15-C. Review of *Witch in the Wilderness* by Desmond Holdridge.

C50 "Summer's Here, So Is New Rosman Romance" [writing as
 A.N.]. *The Cleveland Plain Dealer*, 18 July, Women's Magazine
 and Amusement Section, p. 15-C. Review of *Truth to Tell* by
 Alice Grant Rosman.

C51 "Tale Depicts Historic Ride of Capt. Jouett" [writing as A.N.].
 The Cleveland Plain Dealer, 21 November, Women's Magazine
 and Amusement Section, p. 16-C. Review of *Rising Thunder* by
 Hildegarde Hawthorne.

C52 "Time-Worn Murder Plot Enlivened by New Twist" [writing as
 A.N.]. *The Cleveland Plain Dealer*, 31 October, Women's
 Magazine and Amusement Section, p. 18-C. Review of *Death by
 Invitation* by Gail Stockwell.

C53 "Timely Story About Modern China for Younger Readers"
 [writing as A.N.]. *The Cleveland Plain Dealer*, 31 October,
 Women's Magazine and Amusement Section, p. 18-C. Review of
 China Quest by Elizabeth Foreman Lewis.

C54 "Volume Tells All There Is to Know About West Point" [writing
 as A.N.]. *The Cleveland Plain Dealer*, 26 December, Women's
 Magazine and Amusement Section, p. 18-C. Review of *West
 Point Today* by Kendall Banning.

C55 "Who Killed Dr. Schaedel?" [writing as A.N.]. *The Cleveland
 Plain Dealer*, Women's Magazine and Amusement Section, p. 17-
 C. Review of *The Case of the Seven of Calvary* by Anthony
 Boucher. [not verifiable]

C56 "Woman Finds Career Is Like Barren Fortress" [writing as A.N.].
 The Cleveland Plain Dealer, 4 April, Women's Magazine and
 Amusement Section, p. 16-C. Review of *Today Is Forever* by
 Ramona Herdman.

1938

C57 "Callousness at Sea" [writing as A.N.]. *The Cleveland Plain
 Dealer*, 29 May, All Feature Section, p. 2. Review of *They Sailed
 for Senegal* by D. Wilson MacArthur.

C58 "Other Books Reviewed: *A Pedlars* [*sic*] *Pack* by Elizabeth
 Goudge" [writing as A.N.]. *The Cleveland Plain Dealer*, 9
 January, All Feature Section, p. 2.

C59 "Other Books Reviewed: *Fade Out* by Naomi Jacob" [writing as A.N.]. *The Cleveland Plain Dealer*, 9 January, All Feature Section, p. 2.

C60 "Pens Tale of Oxford in Days of Queen Bess" [writing as A.N.]. *The Cleveland Plain Dealer*, 26 June, All Feature Section, p. 2. Review of *Towers in the Mist* by Elizabeth Goudge.

C61 "Reviewer Praises Sequel to 'A Gay Family'" [writing as A.N.]. *The Cleveland Plain Dealer*, 1 May, All Feature Section, p. 2. Review of *Ballade in G Minor* by Ethel Boileau.

C62 "Riviera Mystery" [writing as A.N.]. *The Cleveland Plain Dealer*, 27 March, All Feature Section, p. 2. Review of *The Clouded Moon* by Max Saltmarsh.

C63 "Story of Cook's Tours" [writing as A.N.]. *The Cleveland Plain Dealer*, 7 August, All Feature Section, p. 2. Review of *The Man from Cook's* by Polan Banks.

C64 "Story of the English Stage 100 Years Ago" [writing as A.N.]. *The Cleveland Plain Dealer*, 18 December, All Feature Section, p. 2. Review of *Old Motley* by Audrey Lucas.

C65 "Tale of a Jilted Lady" [writing as A.N.]. *The Cleveland Plain Dealer*, 22 May, All Feature Section, p. 2. Review of *Miss Dean's Dilemma* by D. E. Stevenson.

C66 "Tale of 100 Years Ago" [writing as A.N.]. *The Cleveland Plain Dealer*, 29 May, All Feature Section, p. 2. Review of *Their Ships Were Broken* by Constance Wright.

1939

C67 Review of *Adriana* by George Dyer [writing as A.N.]. *The Cleveland Plain Dealer*, 4 June, All Feature Section, p. 3.

C68 Review of *Annapolis Today* by Kendall Banning [writing as A.N.]. *The Cleveland Plain Dealer*, 5 March, All Feature Section, p. 3.

C69 Review of *A World in Spell* by D. E. Stevenson [writing as A.N.]. *The Cleveland Plain Dealer*, 9 July, All Feature Section, p. 3.

C70 Review of *Land for My Sons* by Maribelle Cormack and William
 P. Alexander [writing as A.N.]. *The Cleveland Plain Dealer*, 28
 May, All Feature Section, p. 3.

C71 Review of *Miss Bax of the Embassy* by Emily Bax [writing as
 A.N.]. *The Cleveland Plain Dealer*, 14 May, All Feature Section,
 p. 3.

C72 Review of *Royal Escape* by Georgette Heyer [writing as A.N.].
 The Cleveland Plain Dealer, 12 March, All Feature Section, p. 3.

C73 Review of *Spring Journey* by Geneva Stephenson [writing as
 A.N.]. *The Cleveland Plain Dealer*, 18 June, All Feature Section,
 p. 3.

C74 Review of *Strife Before Dawn* by Mary Schumann [writing as
 A.N.]. *The Cleveland Plain Dealer*, 31 December, All Feature
 Section, p. 3.

C75 Review of *Supercargo* by Earl Whitehorne [writing as A.N.]. *The
 Cleveland Plain Dealer*, 14 May, All Feature Section, p. 3.

C76 Review of *The Cut Direct* by Alice Tilton [writing as A.N.]. *The
 Cleveland Plain Dealer*, 15 January, All Feature Section, p. 2.

C77 Review of *The Middle Passage* by Roland Barker and William
 Doerflinger [writing as A.N.]. *The Cleveland Plain Dealer*, 16
 April, All Feature Section, p. 3.

C78 Review of *The Middle Window* by Elizabeth Goudge [writing as
 A.N.]. *The Cleveland Plain Dealer*, 7 May, All Feature Section, p.
 3.

C79 Review of *The Story of Rosabelle Shaw* by D. E. Stevenson
 [writing as A.N.]. *The Cleveland Plain Dealer*, 12 February, All
 Feature Section, p. 2.

1950

C80 "Half-a-Dozen Parties for Children One to Six." *Parents'
 Magazine*, 25 (March), pp. 46-47, 142-145. With Margaret S.
 Young.

1952

C81 "Living in the Year 1980 Plus—." *Library Journal*, 77 (September), pp. 1463-1464, 1466.

1953

C82 "Reserve Your Seat for a Trip to Mars." *The Cleveland Press*, 27 October, Book Fair Supplement, p. 6. Reviews of *The Magic Ball from Mars* by Carl L. Biemiller, *Starman Jones* by Robert A. Heinlein, and *Iceworld* by Hal Clement.

1956

C83 "Introduction." *Stand to Horse* (A30). New York: Harcourt, Brace.

1960

C84 ["Historical Introduction"]. *Shadow Hawk*. New York: Harcourt, Brace.

C85 "Introduction." *The Weirdstone of Brisingamen* [by Alan Garner]. New York: Ace Books [paper].

1961

C86 "Science Fiction Short on Originality, Plot." *The Cleveland Press*, 7 November, Book Fair Supplement, p. 7. Reviews of *Danny Dunn and the Fossil Cave* by Jay Williams and Raymond Abrashkin, *The Star Dwellers* by James Blish, *Moon of Mutiny* by Lester del Rey, and *The Visitors from Planet Veta* by Reinhold W. Goll.

C87 "Top Titles Offered in Fantasy." *The Cleveland Press*, 7 November, Book Fair Supplement, p. 16. Reviews of *The Borrowers Aloft* by Mary Norton, *Tacketty-Packetty House and Other Stories* by Frances Hodgson Burnett, *Dear Rat* by Julia Cunningham, *The Great Rebellion* by Mary Stolz, and *Leopold, the See-Through Crumbpicker* by James Flora.

1962

C88 "Fantasy Field Especially Rich in High-Quality Offerings." *The Cleveland Press*, 5 November, Book Fair Supplement, p. 8. Reviews of *Seven-Day Magic* by Edward Eager, *The Diamond on the Window* by Jane Langton, *Dorrie's Magic* by Patricia Coombs, *A Grass Rope* by William Mayne, and *The Library Mice* by Ann Sanders.

C89 "Science Fiction Moves from Teen-Agers to Younger Group." *The Cleveland Press*, 5 November, Book Fair Supplement, p. 13. Reviews of *A Life for the Stars* by James Blish, *R Is for Rocket* by Ray Bradbury, *Danny Dunn and the Heat Ray* by Jay Williams and Raymond Abrashkin, *The Secret of the Himalayas* by Hal G. Evarts, *Count Down for Cindy* by Eloise Engle, *Spaceship to Planet Veta* by Reinhold W. Goll, and *The Three-Seated Space Ship* by Louis Slobodkin.

1963

C90 "Prologue." *Star Gate*. New York: Ace Books [paper].

1964

C91 "Crop of Fantasy Is a Rich One." *The Cleveland Press*, 3 November, Book Fair Supplement, p. 17. Reviews of *An Enemy at Green* by L. M. Boston, *The Book of Three* by Lloyd Alexander, *Black Hearts in Battersea* by Joan Aiken, *The Witch Who Wasn't* by Jane Yolen, *The Sugar Mouse Cake* by Gene Zion, *The Magic Stone* by Penelope Farmer, *Dorrie and the Blue Witch* by Patricia Coombs, and *The Mouse Palace* by Frances Carpenter.

C92 "Science Fiction Is Scarcer." *The Cleveland Press*, 3 November, Book Fair Supplement, p. 5. Reviews of *Star Watchman* by Ben Bova, *Destination Mars* by Hugh Walters, *The Poison Belt* by Sir Arthur Conan Doyle, and *The Boy's Life Book of Outer Space Stories* (anthology).

1971

C93 "Ghost Tour." *Witchcraft & Sorcery: The Modern Magazine of Weird Tales* [fanzine], 1 (January-February), pp. 29-31.

C94 "On Writing Fantasy." *The Dipple Chronicle* [fanzine], 1 (October-December), pp. 8-11, 30.

Rpt. in *The Many Worlds of Andre Norton*. Ed. Roger Elwood. Radnor, PA: Chilton, 1974, pp. 61-69 (A109).

1972

C95 "Introduction." *Garan the Eternal*. Alhambra, CA: Fantasy Publishing (A93).

1973

C96 "Introduction." *Forerunner Foray*. New York: Viking Press (A99).

C97 ["Introduction to Nicholas Stuart Gray's 'The Star Beast'"]. *Author's Choice 2*. London: Hamish Hamilton.

1974

C98 "Introduction." *Small Shadows Creep* [anthology]. New York: E. P. Dutton (A111).

C99 "Norton Bibliography." *The Many Worlds of Andre Norton*, ed. Roger Elwood. Radnor, PA: Chilton (A109).

C100 "To Make Tamar's Rose Beads and Other Old Delights." In *Lavender-Green Magic* (A107).

1976

C101 "Author's Introduction to This Edition of *Fur Magic*." *The DAW Science Fiction Reader*. ed. Donald A. Wollheim. New York: DAW Books [paper] (A71).

C102 "Introduction." *Baleful Beasts and Eerie Creatures* [anthology] (A119). Chicago: Rand McNally.

C103 "Introduction." *Gate of Ivrel* [by C. J. Cherryh]. New York: DAW Books [paper].

1978

C104 "Foreword: The Girl and the B.E.M." In *Cassandra Rising*. Ed.
 Alice Laurance. Garden City, NY: Doubleday.

1979

C105 "The Origins of the Witch World." *The Norton Newsletter*
 [fanzine], No. 1 (March), p. 2.

1981

C106 "Collecting Science Fiction & Fantasy: Some New Guidelines."
 The Book Mart, December, Vol. 5, #6[7], pp. 3-5, 30, 31.

C107 "Commentaries on the Quest." In *Elfquest Book I*, by Wendy and
 Richard Pini. ed. Kay Richards. Virginia Beach, VA: Starblaze/
 Donning [paper]. p. [3].

C108 "Introduction to *Too Many Magicians*." *Too Many Magicians* by
 Randall Garrett. New York: Ace [paper].

C109 "The Scribbling Women: Magnolias and Melodrama" [Emma
 Dorothy Eliza Nevitte Southworth]. *The Book Mart*, May, Vol. 5,
 #1, pp. 3-7, 10-11, 13-15.

C110 "The Scribbling Women: (Part II of a Continuing Series) A
 Lamp is Lighted: Maria Cummins." *The Book Mart*, July/August,
 Vol. 5, #3, pp. 3, 30.

1982

C111 "Scribbling Women: Susan Warner. Tears, Busy Tears." *The Book
 Mart*, Part 1. February, Vol. 5 #7[*sic.* #9], pp. 3-5, 25, 27; Part 2.
 March, Vol. 5, #8[*sic.* #10], pp. 7-9,25; Part 3. June/July, Vol. 5
 #1 [*sic.* Vol. 6 #1], pp. 7,10-11; Part 4. March 1983, pp. 10-11,
 20-21, 30.

1984

C112 "Bio-page." *The Faces of Science Fiction*, by Patti Perret. New
 York: Bluejay [paper], no page numbers [p. 148?].

1985

C113 "Biographies." In *Magic in Ithkar* (A161).

1988

C115 "20th Anniversary Letters: Dear Charles Brown: " *Locus*, April #327, p. 36.

1989

C114 "Historical Note." In *Imperial Lady* (A181). With Susan Shwartz.

C116 "Series and Sequels, The Problem Thereof." *Andre Norton: Fables & Futures*. Ed. Anne Braude. Center Harbor, NH: Niekas Pubs [paper].

C117 "Speaking of Cats—A Very Weighty Subject." Introduction to *Catfantastic* (A178).

C118 "To the Red Sands of Mars." *Noreascon Three Souvenir Book*. Cambridge, MA: Massachusetts Convention Fandom Inc. Worldcon, August, pp. 11-14.

C119 "A Word from Ms. Norton." *Moonsong* [fanzine], Vol. 1, No. 1 (May), p. 1.

1992

C120 "It is difficult even for a writer..." *Event Horizon* [fanzine] Vol. 5, No. 10 (March). Maitland, FL: OASFiS, p. 9.

1993

C121 "Alicia Austin: 'It has been my great...'" *ConFrancisco —The Souvenir Book*, San Francisco CA: San Francisco Science Fiction Conventions Inc., The 51st Worldcon, September 2-6, p. 15.

C122 "*Locus* Silver Anniversary Letters: 'It has been my pleasure...'" *Locus*, #393, October, p. 40.

C123 "TV's Influence," *TV Guide*, July 24-30, p. 19.

C124 "Years to Come," *Magic Carpet Convention Program Book*
 [fanzine], May 7-9, Dalton, GA, pp. 11-12.

1994

C125 "*Locus* Letter: 'Since we have at last received the IRS ap-
 proval...'" *Locus*, June, p. 72.

C126 "*Locus* Letter: 'Since you were kind enough to back us for the tax
 exempt status...'" *Locus*, July, p. 74.

PART D
CRITICISM, BIOGRAPHY,
AND SELECTED REVIEWS

1938

D01 F. A. C. "*Ralestone Luck.*" *The Cleveland Plain Dealer*, 4 September, Feature Section, p. 2.

Favorable review of *Ralestone Luck* (A02) as an "adventure story of first water for boys and girls." Gives brief synopsis of book and mentions that "Miss. Norton is the A.N. whose reviews appear on this page."

1944

D02 Eaton, Anne T. "For Younger Readers." *New York Times*, 23 April, p. 23. Review of *The Sword is Drawn* (A04).

Abr. in *Book Review Digest* 1944.

Comments favorably on the realistic setting, characters, and plot.

D03 M. G. D. "Lorens Goes to War." *Saturday Review of Literature*, 15 April, p. 75. Review of *The Sword is Drawn* (A04).

Abr. in *Book Review Digest* 1944.

This review expresses admiration for the action, plot, and style of this work but objects to the stylistic use of correspondence at the beginning of each chapter as a method of stressing the theme of international friendship.

1947

D04 Buell, Ellen Lewis. "*Rogue Reynard.*" *New York Times*, 13 July, p. 25. Review of *Rogue Reynard* (A06).

Abr. in *Book Review Digest* 1947.

Norton's coherency of plot and ability to capture the spirit of medieval culture are complimented in this review.

D05 Whitney, Phyllis. "Junior Readers' Roundup." *Cleveland News*, 26 July, Book Section, p. 6. Review of *Rogue Reynard* (A06).

Describes Laura Bannon's drawings as handsome, and reports that in "Miss Norton's skillful hands the old tale emerges with new life and vigor."

1948

D06 Briggs, Elizabeth. "Sea Pirates Battle in Clevelander's Tale." *Cleveland News*, 25 August, p. 7. Review of *Scarface* (A08).

Describes Andre Norton as having sound knowledge of the likes and dislikes of boys and girls. Describes the book as particularly suited to boys and as an "absorbing tale crowded with thrills and not lacking in gore."

1957

D07 Candee, Marjorie Dent, ed. "Norton, Andre." In *Current Biography Yearbook*. 1956-1957. New York: H. W. Wilson.

A brief biography followed by an overview of selected fiction that surveys and classifies the works by genre.

1958

D08 Anon. "Norton, Andre." In *Who's Who of American Women: A Biographical Dictionary of Notable Living American Women*. Vol. I (1958-1959). Chicago: Marquis—Who's Who.

A brief biography that includes employment history and awards.

1960

D09 Donaldy, Ernestine. "She Lives Ahead—In 1980 Plus." *The Matrix*, November-December, pp. 16-17.

An overview and appreciation of Norton's life, fiction, attitudes concerning writing, and conception of science fiction by a friend

and collaborator (A100). *The Matrix* is the publication of Theta Sigma Phi, a national organization for women in journalism, which awarded Norton its Headliner Award in 1965.

D10 Lofland, Robert D. "Andre Norton, A Contemporary Author of Books for Young People." M.A. Thesis, Kent State University.

Begins with a biography that includes information on Norton's professional relations and then surveys her books for young people to 1959. This, combined with Becky D. Peters' thesis (D31), constitutes the best source of biographical information. Lofland's thesis contains a primary bibliography, a brief secondary bibliography, and a list of reviews.

D11 Thompson, Don. "Andre Norton Pens Good One." *Cleveland Press*, November 7, Book Fair Supplement, p. 7. Review of *Catseye* (A43).

Reviewed as a juvenile book.

1962

D12 Patten, Fred. "The Asbestos Shelf." *Salamander* [fanzine], No. 3 (July-August), pp. 5-8.

Although difficult to obtain and current only to 1961, this article is noteworthy as the first examination of Norton's adult and juvenile fiction and as the only attempt to annotate Norton's titles. In the nonbibliographic portion of the article, Patten contends that Norton is an author with one plot: the alienated protagonist who must undergo various rites of passage and ally himself telepathically with noble animals to achieve his manhood. He is also critical of Norton's female characterization (in contrast to Amanda Bankier, D38), but sees more effective efforts in *The Defiant Agents* (A46) in the characterization of Kaydessa, the Mongol woman. In addition, Patten detects a movement away from the stylized plot of the masculine rite of manhood *in Eye of the Monster* (A47) and expresses hope for continued plot variation.

D13 Thompson, Don. "Andre Norton Has New Hit on Science Front." *Cleveland News*, 2 November, Book Fair Supplement, p. 7. Review of *Lord of Thunder* (A48).

Reviewer states that "Andre Norton has found the right mixture of excitement and maturity and has turned out many solid exciting, high-quality science fiction novels." Finds the adventures of Hosteen Storm "exciting and imaginative."

1963

D14 Anon. "Andre Norton." *Westercon XVI Program.* Place and publisher unknown, pp. 33-39.

Formal announcement of awarding of the 1963 Invisible Little Man Award.

D15 [Fisher, Margery]. "Special Review: *Catseye.*" *Growing Point,* 1 (January), p. 97.

Comments on Norton's ability effectively to extrapolate, effectively to confront and represent the half-formed fears of childhood that continue into adulthood, and accurately to assess biological futures and man's estrangement from nature.

D16 Fuller, Michael, ed. "Andre Norton." In *More Junior Authors.* New York: H. W. Wilson.

A good biographical sketch with autobiographical contributions that highlights much of Norton's childhood, formative years, and early writing career.

D17 Kane, Russell W. "The Science Fiction Shelf." *The Cleveland Plain Dealer,* 24 November, p. E-18. Review of *Key Out of Time* (A51).

Brief review of book "pitched at teenagers, this one is way out no matter what the reader's age."

D18 Patten, Frederick. "Andre Norton: A Bibliography 1934-1963." M.L.S. Thesis, University of California at Los Angeles.

An extensively annotated bibliography of the American editions of Andre Norton's novels, short stories, and edited anthologies current to 1963, with an index. Each entry includes full bibliographic information as well as original price and the name of the illustrator.

1966

D19 Carter, Lin. "Andre Norton: A Profile." In *The Sioux Spaceman*. [2nd printing—#F-408]. New York: Ace Books, [paper].

Rpt. in *Star Guard*. [3rd printing—#G-599]. New York: Ace Books, [1966] [paper].

Rpt. in *Secret of the Lost Race*. [2nd printing—#75830]. New York: Ace Books, [1969] [paper].

An evaluation of Norton's entire career and literary output. Current to *Web of the Witch World* (A55) in 1964, the essay contains significant biographical and bibliographical detail with interesting insights into the behind-the-scenes activity at Ace Books. Carter notes that her works have always contained strong fantasy elements and sees the fruition of this quality in the Witch World series, which he praises very highly. In addition, Carter points out that Norton has been a phenomenon in science fiction for three reasons: her works appeal to both juvenile and adult readers; she has rarely published in the genre's magazines; and despite her vivid prose, her entertaining and exciting narrative, and her imaginative invention, she has been largely ignored by serious reviewers; when she has been considered, her works have been largely underrated. However, Carter contends that she must be considered a major figure because of her undeniable skill in a variety of genres, her pioneering efforts in the introduction of quality writing into the field of juvenile science fiction, and her place as a pivotal figure in the development of the interplanetary fantasy sub-genre.

D20 Wilbur, Sharon. "Andre Norton, Her Life and Writings with an Analysis of Her Science Fiction and an Annotated Bibliography." M.L.S. Thesis, Texas Woman's University.

Includes a biography, an analysis of Ms. Norton's science fiction and edited anthologies, and a bibliography with brief annotations, all current to 1965.

1967

D21 Birmingham, Mary Louise. "A Selected List of Children's Books." *Commonweal*, 10 November, pp. 177-178.

Briefly, lauds, summarizes, and evaluates *Octagon Magic* (A66).

D22 Ethridge, James M., and Barbara Kopala, eds. "Norton, Alice Mary." In *Contemporary Authors: A Bio-Bibliographical Guide to Current Authors and Their Works*. Vols. 1-4. Rev. ed. Detroit: Gale Research.

 Rpt. Commire, Anne. *Something About the Author: Facts and Pictures about Contemporary Authors and Illustrators of Books for Young People*. Vol. I. Detroit: Gale Research, 1971.

 An overview of Norton's life, career, and writings with mention of some biographical and critical sources and a short autobiographical statement. The reprinted version contains an autobiographical paragraph and a list or sources. This is superseded by the 1980 edition (D82) and 1990 edition (D120).

D23 Fisher, Margery. "Writers for Children: 8. Andre Norton." *The School Librarian*, 15 (July), pp. 141-144.

 The best of the critical discussions of Norton's fiction as of 1979; now superseded. Recognizes the value of plot and character and the fact that technology and science are secondary elements in Norton's fiction. Fisher correctly identifies and explores the more significant themes and devices of the machine's effect on mankind; intelligence in its many variations, potentials, and alien guises; the importance of animals, sensual imagery, and miscegenation, particularly in *The Beast Master* (A36) and its sequel *Lord of Thunder* (A48); the optimism of new starts and orientations for mankind on other worlds; the symbolic necessity of "earth magic" and an intuitive response to nature; and the quest for self.

1968

D24 Anon. "To the Stars and Back Again." *Times Literary Supplement*, [London], 5 December, p. 1380. Review of *Star Rangers* (A16).

 Calls *Star Rangers* a dynamic narrative of poetic vision written by an author who has the full professional resources of a master.

D25 [Crawford, Wm. L.]. "Introduction to 'Garan of Yu-Lac'." *Spaceway Science Fiction*, 4 (September-October), p. 37.

 A short, but extremely important, introduction that untangles the confused history of "The People of the Crater" (A05) and "Garan of Yu-Lac" (A75) while praising the latter for its vivid

"other world strangeness" and its favorable echoes of the works of
A. Merritt and Edgar Rice Burroughs. Also, see *Garan the Eternal*
(A93) for an important collection of the aforementioned short
stories.

1969

D26 Mallardi, Bill, and Bill Bowers, eds. *The Double: Bill
 Symposium...being 94 replies to 'A Questionnaire for Professional
 Science Fiction Writers and Editors' as Created by: Lloyd Biggle, Jr.*
 [Akron, OH]: D:B Bill Bowers - Bill Mallardi Press.

 An interesting fan publication that provides particular insight
 into Norton's attitudes toward her writing and the science fiction
 genre. In answer to a variety of questions, Norton indicates that
 she likes to alternate between writing science fiction and
 historical-adventure; contends that the chief value of science
 fiction is the "what if..." questions it raises and that it is the "pure
 action relaxation" element of science fiction which is its primary
 relation to mainstream fiction; recommends Charles Fort's books
 on folklore, magic, anthropology, and natural history to the
 beginning writer; argues that the greatest weakness of contempo-
 rary science fiction is self-conscious and pretentious writing; and
 identifies H. Rider Haggard, A. Merritt, Talbot Mundy,
 Dornford Yates, and wide and constant reading as the most
 significant elements in her development as a writer.

1970

D27 McGhan, Barry. "Andre Norton: Why Has She Been Neglected?"
 Riverside Quarterly, 4 (January), pp. 128-131.

 Abr. *Contemporary Literary Criticism* Vol. 12. Ed. Dedria
 Bryfonski. Detroit: Gale, 1980, p. 459.

 Briefly surveys what little critical attention Norton's works have
 received and speculates on the reasons for this neglect. McGhan
 notes her extreme popularity with both adults and juveniles and
 explains that her lack of critical acclaim is due to the general
 neglect of the fantasy genre, the stereotyping of her works as
 escapist, and the unfortunate and incorrect assessment of her as
 "only" an author of juveniles. The essay also explores the major
 elements of Norton's writing—its epic scope, narrative excel-

lence, mystery, complex settings and descriptions, and focus on the relationships between mankind and animals—and contains a chronological and selected bibliography of novels, short stories, and edited anthologies. The next issue of the *Riverside Quarterly*—4 (June 1970), pp. 221-222—contains two interesting letters by Sam Moskowitz and Sandra Miesel responding to McGhan's article.

D28　　Reginald, R., ed. "Andre Norton." *Stella Nova: The Contemporary Science Fiction Authors*. Los Angeles: Unicorn & Son.

Rpt. as *Contemporary Science Fiction Authors: First Edition*. New York: Arno Press, 1975.

Contains a chronological list of novels, collections, and selected short stories current to 1959 plus a brief biographical section that includes awards and memberships in professional organizations. This is followed by a brief autobiographical statement that summarizes the early beginnings of Norton's writing career; her thoughts on science fiction, juvenile literature, and the New Wave science fiction writers; and a list of her favorite authors.

1971

D29　　Brooks, Rick. "Andre Norton: Loss of Faith." *The Dipple Chronicle* [fanzine], 1 (Oct./Dec.), pp. 12-30.

Rpt. in *The Many Worlds of Andre Norton*. Ed. Roger Elwood. Radnor, PA: Chilton. pp. 178-200 (A109).

Abr. *Contemporary Literary Criticism* Vol. 12. Ed. Dedria Bryfonski. Detroit: Gale, 1980, pp. 467-469.

A wide-ranging potpourri that surveys most of the novels up to 1970. Brooks feels that the novels show an evolution toward a pessimistic view of the future and authority, most evidenced by the negative treatment of the social establishment and its police force ("the Patrol"). He also includes mention of the sources of some of the novels [e.g., *Year of the Unicorn* (A60) from Beauty and the Beast, *Warlock of the Witch World* (A68) from Childe Roland and the Dark Tower, *Night of Masks* (A53) from William Hope Hodgson's *The Night Land*] as well as extensive discussion of the negative attitude toward computers and technology. There

are, in addition, descriptions and analyses of the major themes of the bond between man and animal, telepathy, and the aftermath of future war. Concludes that the value of Norton's fiction is its ability to enchant the reader's bond with life, and to offer positive futures through a commitment to nature and intuition.

D30 [Fisher, Margery]. "Special Review: *Plague Ship.*" *Growing Point,* 9 (April), p. 1699.

Examines and expresses admiration for Norton's ability to create narrative tension in *Plague Ship* (A28) and *Sargasso of Space* (A24).

D31 Peters, Becky D. "A Bio-Bibliographical Study of Andre Norton, 1960-1971." M.A. Thesis, Kent State University.

A continuation of Lofland's thesis (D10) which examines all of Norton's fiction published from 1960 to 1971. Divided into five chapters covering the author's life, historical fiction, juvenile fantasy, shorter works, and science fiction. Stresses Norton's role as a female writer and as an artist of evocative prose while examining the major aspects of fear, characterization, and positive rewards in her work. Contains a primary bibliography divided by genre, a brief secondary bibliography, and a list of reviews.

D32 Townsend, John Rowe. "Andre Norton." *A Sense of Story: Essays on Contemporary Writers for Children.* Philadelphia: J. B. Lippincott.

Abr. *Contemporary Literary Criticism* Vol. 12. Ed. Dedria Bryfonski. Detroit: Gale, 1980, pp. 460-462.

In an essay devoted to Norton's works, Townsend indicates that Norton writes primarily space opera and that she is a highly professional writer who effectively creates characters and inventions and who thoroughly researches her works in Greek and Roman mythology, anthropology, archeology, and folklore. He points out that science-for-science's-sake is a very minor element and that her fast-moving, event-oriented narratives demonstrate a negative attitude toward technology. Instead, there is a focus on the success of the intuitive and primitive link between mankind and nature and the special powers and telepathy that this link develops. However, Townsend notes that this precarious blending and juxtaposition of

myth and space technology is occasionally unsuccessful in Norton's savage and hostile settings. Townsend, in addition, compares Norton's fiction to Rosemary Sutcliff's in its use of the ancient and mythical themes of instinctual life, the seasons, and life and death. He contends that these themes are best expressed in *Dark Piper* (A70). The chapter also examines *Star Man's Son 2250 A.D.* (A12), *Star Rangers* (A16), *Star Guard* (A25), *Star Gate* (A34), *The Beast Master* (A36), *Lord of Thunder* (A48), *Judgment on Janus* (A50), and *Victory on Janus* (A64). A chronological bibliography of the British and American first editions of the novels, current to 1971, and a brief autobiographical summary of Norton's career are appended to the chapter.

D33 Ward, Martha E., and Dorothy A. Marquardt. "Norton, Alice Mary." *Authors of Books for Young People*. 2nd ed. Metuchen, NJ: Scarecrow Press.

A brief bio-bibliographic entry that identifies some of the genres of Norton's works, the highpoints of her life, and seven of her juvenile titles.

1972

D34 Walker, Paul. "An Interview with Andre Norton." *Luna Monthly*, No. 40 (September), pp. 1-4.

Rpt. *Speaking of Science Fiction: The Paul Walker Interviews*. Oradell, NJ: Luna Publications, 1978 [paper].

A strong source of information on family and past life, literary style, narration and plot, sources, attitude toward the evolution of series (e.g., *Witch World*, A52), and Norton's role within the science-fiction genre.

1973

D35 Anon. "Sorcery for Initiates." *Times Literary Supplement*, [London] 28 September, p. 1114. Review of *The Crystal Gryphon* (A89).

Abr. *Contemporary Literary Criticism* Vol. 12. Ed. Dedria Bryfonski. Detroit: Gale, 1980, p. 465.

While Norton's novels are frequently called juvenile, her wide-ranging works, in actuality, appeal to anyone over the age of twelve. Much of this is due to the historical, mythical, and legendary backgrounds of her works as well as her high tone, epic seriousness, dark and brooding sense of Senecan tragedy, sense of fate, subtle plotting, and elemental symbolism. Favorably compares Norton to Rosemary Sutcliff in that both "share a common theme… [of] the heroic tale which generates a linguistic and tonal similarity, difficult for the novice, spellbinding for the initiate." The most astute of the many reviews of Norton's works.

D36 Carter, Lin. ["Introduction to 'Toads of Grimmerdale'"]. *Flashing Swords! #2.* Ed. Lin Carter. Garden City, NY: Nelson Doubleday [Science Fiction Book Club].

Carter expresses admiration for the rich setting and adult character development of the Witch World series, in general, and this Witch World short story, in particular.

1974

D37 Anon. "Beyond mere SF." *Times Literary Supplement,* [London] 20 September, p. 1006. Review of *Uncharted Stars* (A78).

Contends that Norton's usual excellence of narration and characterization are lost in a preoccupation with plot.

D38 [Bankier, Amanda]. "Women in the Fiction of Andre Norton." *The Witch and the Chameleon* [fanzine], 1 (August), pp. 3-5.

Correctly indicates that Norton was using realistic female characters and confronting the issues of sexism long before it was fashionable. Examines the female characters of the Witch World series, *Storm Over Warlock* (A42), *Ordeal in Otherwhere* (A54), *Dread Companion* (A79), *Moon of Three Rings* (A62), *Exiles of the Stars* (A86), *Android at Arms* (A85), and *Breed to Come* (A88). The essay also comments on her ability to shape the masculine-dominated genre of sword and sorcery to allow for female emphasis (also see D12).

D39 Blishen, Edward. "Obstructs, Mind-seals and Distorts." *Times Educational Supplement,* 29 March, p. 24. Review of *Forerunner Foray* (A99) and *The Zero Stone* (A73).

Objects to the stereotyping of Norton as a juvenile author and describes her as "one of those curious, intricate, and passionately odd and persuasive imaginations that can create and sustain a fantasy universe...."

D40 [Turner, David G.] *The First Editions of Andre Norton.* Menlo Park, CA: David G. Turner, Bookman [paper].

A chronological bibliography of books, magazine fiction, edited anthologies, and articles that is current to 1973. Since it is incomplete and has a few errors, this effort is most valuable for its identification of the genres of the novels and the appended listing of Norton's series. See also C99 and D44.

D41 Wollheim, Donald A. "Introduction." *The Many Worlds of Andre Norton.* Ed. Roger Elwood. Radnor, PA: Chilton (A109).

Abr. *Contemporary Literary Criticism* Vol. 12. Ed. Dedria Bryfonski. Detroit: Gale, 1980, pp. 466-467.

Argues that Norton is unjustly ignored as a major figure because of her lack of publications in the standard science-fiction magazines, her few short stories, her absence at science-fiction conferences, and the incorrect marketing of her science fiction as juveniles. Wollheim points to the success of the paperback editions of her works as evidence of her nonjuvenile appeal. He attributes her popularity to the pleasure that her books generate, her sense of alien minds and environments, her realistic characters, her compassionate use of animals, and the elements of wonder and love in her works.

1975

D42 Burke, James K. Review of *The Book of Andre Norton* (A109). *Delap's F & SF Review* (October), pp. 21-22.

Praises Brooks' "Andre Norton: Loss of Faith" (D29) as an unbiased evaluation and indicates that Norton's "On Writing Fantasy" (C94) is a special treat. Views the collected fiction as mixed in its quality.

D43 Hayes, Sarah. "Far flung worlds." *Times Literary Supplement,* [London] 19 September, p. 1052. Review of *Iron Cage* (A105) and *The Jargoon Pard* (A106).

Accurately describes the unusual range of Norton's fiction and examines her talent for effectively using magic and her ability to endow her historical settings with a true sense of place.

D44 Hewitt, Helen-Jo Jakusz. "Andre Norton Bibliography." In *The Book of Andre Norton*. Ed. Roger Elwood. New York: DAW Books [paper], pp. 211-221.

A revision of Andre Norton's own bibliography of her works that appeared in *The Many Worlds of Andre Norton* (C99). Like the original, it is arranged alphabetically and includes the publishing history of the short stories, books, collaborations, short story collections, edited anthologies, and non-fiction. It is updated from the original to include works published in 1974 and some of those appearing in 1975. Each entry contains genre identifications and series notations. Omits some of the non-fiction and some of the short story appearances as well as citing a number of Canadian editions which do not exist. Also see C99, D40, and D18.

D45 Houston, B. R. Chris. "SF Speakout: Andre Norton." *SF Forum*, January, pp. 21-22.

D46 Patten, Frederick. Review of *No Night Without Stars*. *Delap's F & SF Review* (November), pp. 12-13.

Sees *No Night Without Stars* (A116) as a tightly written and exciting novel that is reminiscent of *Star Man's Son 2250 A.D.* (A12). Recommends the novel as a necessary library acquisition.

D47 Morgan, Eamon. Review of *The White Jade Fox*. *Delap's F & SF Review* (August), pp. 15-16.

Pays tribute to Norton's influence and impact on the field of science fiction and strongly admires the high quality and effective plotting of this first excursion into the Gothic genre (A'118).

1976

D48 Ash, Brian. "Andre Norton." *Who's Who in Science Fiction*. Ed. Brian Ash. New York: Taplinger; London: Hamish Hamilton.

A brief bio-bibliographic entry.

D49 Berman, Ruth. Review of *Knave of Dreams*. *Delap's F & SF Review* (May), pp. 15-16.

 Knave of Dreams (A114) is a good example of Norton's fiction which combines attractive characters, a strong plot, and a well-visualized setting.

D50 Carter, Lin. "Andre Norton." *Flashing Swords! #3: Warriors and Wizards*, Ed. Lin Carter. [New York]: Dell [paper].

 Remarks on the unexpected subtlety, maturity, and major change in style and pace in the Witch World series in introducing "Spider Silk" (A122).

D51 Cohen, Sandy. Review of *The Jargoon Pard*. *Delap's F & SF Review* (April), pp. 21-22.

 An excellent illustration of the dramatic quality of sword and sorcery fantasy with strong characterization and a well conceived setting (A106).

D52 Hunt, Peter. "World Weary." *Times Literary Supplement*, [London] 1 October, p. 1242. Review of *No Night Without Stars* (A116) and *Knave of Dreams* (A114).

 Praises Norton's plot movement and settings in *No Night Without Stars* and lauds both novels for their narrative confidence and certainty. Questions, however, the apparent inappropriate use of archaic language.

D53 Manly, Seon, and Gogo Lewis, eds. [Introduction to "Through the Needle's Eye" (A83)]. *Sisters of Sorcery: Two Centuries of Witchcraft Stories by the Gentle Sex*. New York: Lothrop, Lee and Shepard, pp. 29-30.

 Comments on the theme of sewing in myth and literature and Norton's use of the theme in this particular short story (A83). Includes a brief biographical sketch and a brief evaluation of Norton's status as a major writer of science fiction and fantasy.

D54 Molson, Francis J. Review of *Star Ka'at*. *Delap's F & SF Review* (October), pp. 17-18.

 While praising Norton, finds *Star Ka'at* (A117) too contrived and pedantic to be on a par with her other juveniles.

D55 Patten, Frederick. Review of *Wraiths of Time*. *Delap's F & SF Review* (November), pp. 21-22.

Notes Norton's use of black and female characters but finds *Wraiths of Time* (A123) bewildering and disappointing. On the basis of her past performances, Patten is particularly critical of Norton's "world-building."

D56 Warlow, Aidan. "Post-Nuclear Perils." *Times Literary Supplement*, [London] 16 July, p. 878. Review of *The Crossroads of Time* (A27) and *Outside* (A110).

Prefers *Outside* to *The Crossroads of Time* and sees the latter as being too preoccupied with psi powers to do more than establish stereotyped characters.

1977

D58 Miesel, Sandra. "Bibliography of Andre Norton's Witch World." *Witch World*. Boston: Gregg Press (A52).

An alphabetical list of all the short stories and novels in Norton's Witch World series. More recent publications, as cited in D57 above, should be added.

D57 _____ . "A Chronological Chart of Andre Norton's Witch World Novels Indicating Time and Geographical Relationships." *Witch World*. Boston: Gregg Press (A52).

A valuable chart that explains the chronology and settings of the Witch World short stories and novels. Due to the publication date of this Gregg reprint and Miesel's commentary (See D58 and D59), "Sword of Unbelief" (A128), the [then] forthcoming "Sand Sister," (A137) and the short stories collected in *Trey of Swords* (A129)—"Sword of Lost Battles" (A126), "Sword of Ice" (A125), and "Sword of Shadow" (A127)—are not included.

D59 _____ . "Introduction." *Witch World*. Boston: Gregg Press (A52).

Beginning with an overview of Norton's career and popularity, Miesel discusses the reasons for the lack of attention Norton's work has received and proceeds to an evaluation of her fiction, in general, and of the Witch World series, in particular. Norton's

works are characterized by their spirit of adventure and their emotional appeal. Science is secondary to human and understandable concerns, and the ideas expressed in the fiction are necessarily related to humanistic elements: parapsychology, animals, archaeology, folklore, anthropology, and history. Throughout, the narrative is always a primary concern, and her characters are uniformly presented with difficult moral decisions which are often made in confrontation with technology or power groups and most often are made for positive, humanistic reasons. In the second portion of Miesel's introduction, there is an explanation of the history, geography, and peoples of the Witch World. Intermingled in this discussion are indications of the sources of the series. After briefly summarizing the various novels and short stories of the Witch World series, the various thematic concerns of the series are explored with particular emphasis on the motifs of power, personal realization, and the evil of technology. The essay concludes with a strong examination of the role of women in Norton's works.

D60 Ruse, Gary Alan. "*Algol* Profile: Andre Norton." *Algol*, 29 (Summer-Fall), pp. 15-17.

An overview of Norton's life, career, and interests that contains valuable information on her earlier and non-science fiction publications: *Ride Proud, Rebel!* (A44), *Rebel Spurs* (A49), *The Prince Commands* (A01), and *Murders for Sale* (A20).

1978

D61 Anon. "*Merlin's Mirror.*"(A115) *Science Fiction Special* (27). London: Sidgewick & Jackson.

D62 Beeler, Thomas T. "Introduction." *The Time Traders*. Boston: Gregg Press.

The introduction to the Gregg Press reprints of the Time Trader novels: *The Time Traders* (A35), *Galactic Derelict* (A37), *The Defiant Agents* (A46), and *Key Out of Time* (A51). Contains a very brief biography, a discussion of the erroneous belief that Andre Norton is a pseudonym (see the Introduction to this volume), and an overview of Ms. Norton's early general fiction and science fiction. In the more lengthy examination of the Time Trader novels, Beeler discusses the sources; the series' genesis; the

individual plots; the characterization; and the major themes of survival, conflict between individual and group, and the human simplicity of the past versus the dismal complexity of the future. There is one major error, apparently initiated by Barry McGhan (D27) and perpetuated by Sandra Miesel (D59 and D65) and Beeler, that should be noted. The contention that *Star Hunter* (A45) was nominated for a Hugo Award (p. vi) is not supported by Donald Franson and Howard DeVore's *A History of the Hugo, Nebula, and International Fantasy Awards* (rev. ed. Dearborn, MI: Howard DeVore, 1975 and 1985).

D63 Culpan, Norman. "Norton, Andre." *Twentieth-Century Children's Writers*. Ed. D. L. Kirkpatrick. New York: St. Martin's Press.

Contains an adequate bibliography of Ms. Norton's fiction and edited anthologies, divided into children, and adult titles, that is followed by a brief statement of her writing interests by Ms. Norton and a brief analysis of the nature of her fiction by Culpan.

D64 Linaweaver, Brad. "The *Squonk* Interview: Andre Norton." *Squonk* [fanzine], 1, No. 2 (March/April), pp. 18-20, 27.

Ms. Norton discusses her continuing goals and objectives, the influences on her fiction, her themes, cats, and her views on the writings of Harlan Ellison, Robert A. Heinlein, and J. R. R. Tolkien.

D65 Miesel, Sandra. "Introduction." *Sargasso of Space*. London: George Prior; Boston: Gregg Press.

Rpt. *Lan's Lantern* 16 [fanzine], March 1985, pp. 21-26.

A brief introduction to Ms. Norton's career followed by an analysis of her Space Adventures (occasioned by Gregg's reprints of the volumes): *Sargasso of Space* (A24), *Plague Ship* (A28), *Voodoo Planet* (A39), *Star Hunter* (A45), *The Crossroads of Time* (A27), *Secret of the Lost Race* (A38), and *The Sioux Spaceman* (A41). Aspects of the series that are considered include setting, characterization, mythic themes and patterns, the creation of future history, animal imagery and characters, and the general place of the Space Adventure novels amid Ms. Norton's fiction.

1979

D66 Allen, Beth. Review of *Red Hart Magic* (A121). *Science Fiction &*
 Fantasy Book Review, December, p. 164.

D67 Baker, Stan, and Holly Shissler. "Andre Norton Survey—Part
 One—*Witch World*." *The Norton Newsletter* [fanzine], March, pp.
 5-7.

D68 _____. "Andre Norton Survey—Part Two—*Web of the Witch*
 World." *The Norton Newsletter* [fanzine], June, pp. 4-7.

D69 Brooks, Rick. "Andre's Animals." *The Norton Newsletter*
 [fanzine], December, pp. 2-3.

 Rpt. in *Lan's Lantern 16* [fanzine], March 1985, pp. 8-9.

 An overview of the animals in Andre Norton's books in regard to
 the theme of man and beast working together. Mentions that
 Andre Norton doesn't invent animals but uses natural histories
 and takes the characteristics of little-known existing animals.

D70 _____. "Bruno Bettelheim and *Year of the Unicorn*." *The Norton*
 Newsletter [fanzine], No. 1 (March), pp. 4-5.

 Rpt. in *Lan's Lantern 16* [fanzine], March 1985, pp. 21-26.

 Drawing upon Bruno Bettelheim's *The Uses of Enchantment: The*
 Meaning and Importance of Fairy Tales, Brooks discusses the use
 of the folk tale of Beauty and the Beast as a source for *Year of the*
 Unicorn (A60) and examines Ms. Norton's considerable reshap-
 ing of the tale for the novel. Brooks puts particular stress on the
 rites of passage undergone by the novel's protagonist, Gillan.

D71 Currey, L. W. "Norton, Andre." *Science Fiction and Fantasy*
 Authors: A Bibliography of First Printings of Their Fiction, Boston,
 MA: G. K. Hall & Co. pp. 388-389.

 This is complete until 1979 and is good for identifying the
 differences among the first edition, first printing, and later
 printings.

D72 Elgin, Suzette Haden. Review of *Seven Spells to Sunday* (A138).
 Science Fiction & Fantasy Book Review, May, p. 51.

D73 Molson, Francis J. Review of *Quag Keep* (A132). *Science Fiction & Fantasy Book Review*, March, p. 17.

D74 Patten, Frederick. Review of *The Crossroads of Time* (A27). *Science Fiction & Fantasy Book Review*, February, pp. 7-8.

Abr. *Contemporary Literary Criticism* Vol. 12. Ed. Dedria Bryfonski. Detroit: Gale, 1980, pp. 471-472.

In the *Crossroads of Time* the action and tension remain constant, and the settings are fascinatingly exotic.

D75 Schlobin, Roger. "Andre Norton and Her Sources." *The Norton Newsletter* [fanzine], December, pp. 5-6.

D76 _____. "*Here Abide Monsters* (A101)." *Survey of Science Fiction Literature*. Ed. Frank N. Magill. Englewood Cliffs, NJ: Salem Press, Vol. II, pp. 969-971.

The plot device of unexplained disappearances, which have been recorded throughout history, is used to transport two teenagers to a parallel world where the native inhabitants have the mystical elements of the Arthurian legends. The plot hinges around the ability of the two teens and other similarly transported humans to face and accept change and growth.

D77 _____. "*Star Man's Son 2250 A.D.*" (A12) *Survey of Science Fiction Literature*. Ed. Frank N. Magill. Englewood Cliffs, NJ: Salem Press, Vol. V, pp. 2156-2158.

Describes how the plot illustrates central features of Andre Norton's fiction: characters that are isolated and driven, lack of prejudice, and stress on internal value.

D78 Searles, Baird, Martin Last, Beth Meacham, and Michael Franklin, eds. "Andre Norton," *A Reader's Guide to Science Fiction*. Avon [paper], p.132.

Attempt to tell the reader if they will like the books written by the authors listed. Andre Norton considered an author of juvenile books because of the age of the protagonists. "Fascinating people and places abound."

D79 Souza, Steve. "The Past Thru Today." *FAD* [fanzine], No. 2 & 3
 [February], n. p.

D80 Weinkauf, Mary S. "The Indian in Science Fiction." *Extrapola-
 tion*, 20, pp. 308-320.

 Discusses *The Beast Master* (A36), *Lord of Thunder* (A48), and
 The Sioux Spaceman (A41).

D81 Yoke, Carl. *Roger Zelazny and Andre Norton: Proponents of
 Individualism*. Columbus: The State Library of Ohio [paper].

 This valuable study is one of the few scholarly examinations of
 Norton's major characters. The relationship between her canon
 and Zelazny's reveals common themes of alienation, indepen-
 dence, self-reliance, and self-realization that are realized through
 the protagonists. This is difficult to find, but well worth the
 effort.

1980

D82 Anon. "Norton, Alice Mary 1912-." *Contemporary Authors—
 New Revision Series*. Vol. 2. Ed. Anne Evory, Detroit, MI: Gale
 Research, pp. 509-511.

 A brief biography and a bibliography of titles and dates and
 publishers of first printings. Mentions that certain themes occur
 throughout Norton's books, that these books are a cut above the
 usual science-fiction action-adventure tales because of the
 author's vivid and detailed descriptions, specifically that the
 worlds Norton creates are believable. "Although her books are
 aimed at the young adult market, Norton has acquired a
 substantial following among adult readers." Superseded by 1990
 edition (D120).

D83 Fraser, Brian M. "Putting the Past into the Future, Interview
 with Andre Norton." *Fantastic Science Fiction*. Vol. 27, No. 11
 (October), pp. 4-9.

D84 Hensley, Charlotta Cook. "Andre Norton's Science Fiction and
 Fantasy, 1950-1979: An Introduction to the Topics of Philo-
 sophical Reflection, Imaginary Voyages, and Future

 Prediction in Selected Books for Young Readers." Ph.D. disserta-
 tion, University of Colorado at Boulder. DAI, 41: 3580A.

D85 Schlobin, Roger C. *Andre Norton: A Primary and Secondary Bibliography*. Boston: G. K. Hall. [ISBN 0-8161-8044-X]

1981

D86 Holdom, Lynne. "A Look at Andre Norton's Work." *Tightbeam* [fanzine]. No 30, Pompton Lakes, NJ: May[July?], pp. 13-14.

Mention of how Andre Norton got the reviewer intrigued with the what-ifs of history. Reviews the Crosstime Agents series and the Time Traders series.

D87 Miller, Rob. "Andre Norton: A Brief Overview." *Tightbeam* [fanzine]. No 30, Pompton Lakes, NJ: May[July?], pp. 7-10.

Mentions some of Andre Norton's major themes and some of Miller's favorite books as well as a suggested book list of authors the reader might also like.

D88 Schlobin, Roger C. "Andre Norton." *Twentieth Century Science Fiction Writers*. ed. Curtis C. Smith. New York: St. Martin's, pp. 401-403.

A bibliography and an overview of the major themes and motifs of Andre Norton's fiction: "technology and science are incidental to plot and character", "jewels and psychometry", humanity and self-realization, and characters who are alone, alienated, fearful, and searching, who then achieve the nobility and status of the healer as they cure themselves and others.

D89 Sparks, Elisa Kay. "Andre Norton." *Twentieth Century American Science Fiction Writers*. Ed. David Cowart and Thomas L. Wymer. Detroit: Gale Research, II, pp. 53-56.

A selected list of books followed by a bibliographic review of books and themes. Again the comments: "Norton's status as a science-fiction writer is not critically well-established...The problem seems to be more that the academics do not consider her to be a 'serious' enough writer. Part of the trouble may be her habit of first publishing her novels as hardcover 'juveniles.'"

D90 Woodbury, Kathleen. "The Promise of the Witch World." *Tightbeam* [fanzine]. No 30, Pompton Lakes, NJ: May[July?]. p. 11.

Brief look at the Witch World stories, with the major premise that the protagonists are easy to identify with.

1982

D91 Schlobin, Roger C. "Andre Norton: Humanity Among The
 Hardware." *The Feminine Eye: Science Fiction and the Women
 Who Write It.* Ed. Tom Staicar, New York: Frederick Ungar, pp.
 25-31.

 References the Introduction to the 1980 edition of this work,
 and repeats much of the information on the influences on Andre
 Norton's work. Rather than pursuing the technologies of the new
 ages, Norton stresses portrayal of her characters. The novels are
 filled with the threatening forces, made by humans. Gadgetry
 just is. Spaceships are as ordinary as buses.

D92 _____. "The Dragon's Well." *Fantasy Newsletter*, March, pp.
 24-25. Review of *Horn Crown* (A147) and *The Crystal Gryphon*
 (A89).

D93 Searles, Baird, Beth Meacham, and Michael Franklin. "Andre
 Norton." *A Reader's Guide to Fantasy.* New York: Avon, pp. 121-
 122 [paper].

 A brief and inaccurate survey of Norton's career.

D94 Wahlstrom, Billie Jo. "Alice Mary Norton." *American Woman
 Writers.* Ed. Lina Mainiero. New York: Ungar, Vol. 3, pp. 278-
 281.

 A short review of Norton's novels, highlighting early work and
 only mentioning the Witch World series in passing. Bibliography
 through 1978.

1983

D95 Platt, Charles. "Andre Norton." *Dream Makers, Volume II.*
 Berkley [paper].

 Interview with Andre Norton in her home. Good expression of
 the atmosphere, her inspirations, her work habits and interests.

D96 Schlobin, Roger C. "The Witch World Series by Andre Norton."
 Survey of Modern Fantasy Literature. Ed. Frank N. Magill and
 Keith Neilson. La Canada, CA: Salem Press, pp. 2139-2149.

Sources of the Witch World series plot are given. Divisions of the Witch World are described. Andre Norton uses notebooks to keep track of characters. This is an extensive review of the series, noting that "In true Norton fashion there are still mysteries to be solved."

1984

D97 Anon. "Otherworldly Women." *Life Magazine,* Vol. 7, No. 8 (July), pp. 112-113.

Andre Norton Photo Story.

1985

D98 Boss, Judith E. "Elements of Style in Science Fiction: Andre Norton Compared with Others." *Extrapolation,* Vol. 26, No. 3 (Fall), pp. 201-211.

Uses a computer tabulation of the number of words, sentences, and sentence length to compare several Andre Norton stories to the stories of some other authors.

D99 D'Ammassa, Don. "Andre Norton: Short Story Writer." *Lan's Lantern 16* [fanzine], March, pp. 28-29.

Contains plot summaries of many of Andre Norton's short stories.

D100 Dickholtz, Daniel. "100 Most Important People: Andre Norton." *Starlog 100,* November, pp. 14-15.

An historical overview discussing two books for each of two of Andre Norton's most used themes.

D101 Hills, Greg. "A Review of *'Ware Hawk* (A154)." *Lan's Lantern 16* [fanzine], March, pp. 31-33.

D102 Laskowski, George "Lan", ed. *Lan's Lantern 16* [fanzine], March.

Contains two dozen articles, letters, and illustrations on Andre Norton and her books. Some of these articles are given separate listings here.

D103 Lichtenberg, Jacqueline. "Thank You Andre." *Lan's Lantern 16*
 [fanzine], March, p. 45.

 Lichtenberg says that her Dushau universe is a new background
 to the story in *Star Rangers* (A16). "So I will remain forever a
 Norton fan. And I hope to travel a ways along the road she has
 forged for us all—not to escape from reality, but into it."

D104 Owings, Mark. "Andre Norton Bibliography." *Lan's Lantern 16*
 [fanzine], March, pp. 36-43.

 Alphabetical attempt to include most editions and printings,
 prices and page counts, foreign titles included. This is hard to
 read.

D105 Schlobin, Roger. "Andre Norton: Updates, Additions and
 Corrections to Andre Norton: A Primary and Secondary
 Bibliography." *Lan's Lantern 16* [fanzine], March, pp. 12-16.

 Primary source for the items included herein. Does not include
 annotations.

D106 Shea, David M. "The Calendar and Chronology of Witch
 World." *Lan's Lantern 16* [fanzine], March, pp. 18-19.

 An attempt to fit the Witch World stories, to date, into a time
 line using the [twelve] years named for various creatures.

D107 Shwartz, Susan. "Andre Norton: Beyond the Siege Perilous,"
 Moonsinger's Friends. Ed. Susan Shwartz. New York: Bluejay
 [paper], pp. 1-3.

 Describes the book *Moonsinger's Friends* as a recognition of
 Andre Norton, "the woman who opened Gates to many of us
 and who, as writer, mentor, and friend, has been 'the gateway
 through which so, so many of us have come into this field in the
 first place.'"

D108 Shwartz, Susan, ed. *Moonsinger's Friends*, New York: Bluejay
 [paper], pp. 1-3. [The later 1986 Tor paper edition is easier to
 find.]

 This book is an anthology of stories written in honor of Andre
 Norton.

D109 Vinge, Joan D. "An Open Letter to Andre Norton." *Lan's Lantern 16* [fanzine], March, pp. 5-7.

Rpt. Shwartz, Susan, ed. *Moonsinger's Friends.* New York: Bluejay, pp. 1-3.

Includes some biographical material and some of the "Sense of Wonder" gotten from reading Andre Norton adventures. There are lessons learned from seeing all people as equals and having female protagonists and stories where even all-male casts avoid demeaning portrayals of women. Andre Norton has provided literary role models and is a role model.

D110 Yoder, Carl. "The Coming of Age Theme in Selected Works of Andre Norton." *Lan's Lantern 16* [fanzine], March, pp. 34-35.

Explores the theme using several of Andre Norton's books, including *Stand to Horse* (A30) and *Rebel Spurs* (A49).

1986

D111 S[chlobin], R[oger] C. "Andre Norton." *The Arthurian Encyclopedia*, Ed. Norris J. Lacy. New York: Garland, p. 408; rev. ed. as *The New Arthurian Encyclopedia*, 1991.

Very short plot synopses of *Merlin's Mirror* (A115) and *Steel Magic* (A57) and their treatment of the Arthurian legend. The 1991 edition adds synopses of *Dragon Magic* (A90), *Huon of the Horn* (A11), and *Witch World* (A52).

D112 Smith, Karen Patricia. "Claiming a Place in the Universe: the Portrayal of Minorities in Seven Works by Andre Norton." *Top of the News*, Winter, pp. 165-171.

Tries to make the point that Andre Norton "has used her literary vision to explore the 'fantastic' situations of minorities in both future and other worldly environments." Uses the Star Ka'at Series, Hosteen Storm, *Star Man's Son* (A12), and *Sea Siege* (A31), but the impression given by these examples is more that the different races and species treat each other as equals.

1987

D113 Cherryh, C. J. "Andre Norton: A Perspective," *Noreascon 3, Progress Report 1*, January, Cambridge, MA: Massachusetts Convention Fandom Inc., pp. 9-12.

Andre Norton's way of working is more purely the storyteller's art, where people can identify with the characters. "Andre Norton helped no few of us through our own identity crises." Andre Norton is described as a master at world-building whose creative output continues.

D114 Garcia, Nancy, and Mary Frances Zambreno. "Andre Norton, Interview and Bibliography." *American Fantasy*, Winter, Vol. 2, No. 2, pp. 22-25.

An interview presented as a biography. Andre Norton sees mental pictures that she then describes for the reader. She tries to open the book with a vivid scene and end each chapter with a cliffhanger. A list of honors and a bibliography are included.

1989

D115 Anon. "Biography." *Moonsong* [fanzine], Vol. 1, No. 1, May, pp. 1-4.

A short biography, uncredited, but probably by Gwen Hamon, who ran the fan club.

D116 Baty, Kurt. "The Whole Science Fiction Data Base: Andre Norton." *Noreascon Three —The Souvenir Book*. Cambridge, MA: Massachusetts Convention Fandom, August, pp. 165-177.

First notation of *Maid-at-Arms* (A148), confirmed by Andre Norton and by using the collection of Syracuse University Library. Gives detailed computer listing of each separate edition of all of Andre Norton's books. Lists publishers, dates, printings, and cover artists. Lots of minor typing errors.

D117 Braude, Anne, ed. *Andre Norton: Fables & Futures*. Center Harbor, NH: Niekas Publications [paper].

This is an anthology of pieces on Andre Norton. The major piece is by Ann Braude, "Andre Norton's Rites of Passage." The main

theme of the piece is a definition of fantasy and how Andre Norton shows the way to believe in fairy tales. There is also an article by Marion Zimmer Bradley, "A Rather Prolific Hobbyist," which describes how the *Black Trillium* book came about and several other personal anecdotes.

D118 Crispin, A. C. "Queen of the Witch World: Andre Norton," Part 1. *Starlog*, Issue #146, September, pp. 33-36, 52; Part 2, *Starlog*, Issue #147, October, pp. 54-57, 96.

Lots of book cover photos and two nice photos of Andre Norton, one with and one without cats. Interview covers early years and the Witch World series. The second half covers lost manuscripts, proposed projects, and mentions the *Beastmaster* movie. During the interview Andre states that her name "without the accent is the feminine version of the name."

D119 Miller, Sasha, and Ben W. Miller, eds. *Gurps Witch World Roleplaying in Andre Norton's Witch World.* Austin, TX: Steve Jackson Games Inc.

Intended as the elaborate rule book for a role-playing game. In actuality, this is a good compilation of all of the Witch World stories. In this the time line never repeats names. There may be errors in time line or details, but these can be excused as the necessities of uniting various stories into a whole. Concludes with a Bibliography, Glossary, and Index.

D120 Telgen, Diane. "Norton, Andre 1912-." *Contemporary Authors: A Bio-Bibliographical Guide to Current Writers in Fiction, General Fiction, Poetry, Journalism, Drama, Motion Pictures, Television, and Other Fields.* New Revision Series, Vol. 31. Ed. James G. Lesniak. Detroit: Gale Research.

Bibliography is by genre and then sorted by year of publication through 1989. The majority of the article consists of paragraph summaries of critical sources.

D121 Vinge, Joan. "Andre Norton: To the Mother of Us All." *Noreascon Three—The Souvenir Book.* Cambridge, MA: Massachusetts Convention Fandom Inc., August. pp. 14-18.

Andre Norton's books, like Heinlein's, were often the first science-fiction book that many fans started with. The reader

stays with that book because of the "sense of wonder" it evokes.
Andre Norton's continued popularity stems from the fact that
the books transport readers with wonder. Her most important
contribution is that she was one of the first "who wrote socially
aware, humanistic science fiction." Andre Norton "laid the
groundwork for most of today's writers of sociological and
anthropological sf."

1991

D122 Anon. "Andre Norton: Living Legacy." *Locus* [fanzine], Vol. 29,
 No 6, Issue #365, June, pp. 4, 65.

 Interviewer probably Charles N. Brown, but unaccredited.
 Discusses Andre Norton's collaborations. Mentions *The Day of
 the Rat* as the sequel to *The Mark of the Cat* (A198). Discusses
 other future projects.

D123 Shwartz, Susan. "An Interview with Andre Norton." *Marion
 Zimmer Bradley's Fantasy Magazine*, #12 (Spring), pp. 35-37.

 Andre Norton has earned special respect from women writers, as
 well as their male colleagues. Andre Norton is a gate keeper, but
 lets you into her worlds again and again. Brief interview discusses
 Andre Norton's start in writing, what she was currently working
 on and her discovery of new writers. "The readers deserve the
 best work I am able to deliver."

D124 Yoke, Carl B. "Slaying the Dragon Within: Andre Norton's
 Female Heroes." *Journal of the Fantastic in the Arts*. 4(3): pp. 79-
 92.

 The female heroes of Andre Norton's books are initially made to
 feel inferior or are similarly repressed by their cultures. They are
 different and this alienates them from those around them.
 "Norton's female heroes not only learn that their differences are
 not a disadvantage but that they are, in fact, real assets." In
 Norton's stories the female hero reaches a state of integrated
 wholeness which is often symbolized by bonding with a male,
 but the relationship fits the new self as the female hero.

D125 Stephensen-Payne, Phil. *Andre Norton: Grand Master of the Witch World, A Working Bibliography.* Albuquerque, NM: Galactic Central.

A very good listing, with titles in alphabetical order and a single date line for the index. However, has one error, of including a non-fiction work by Alice Norton, *Your Public Library.*

1993

D126 Anon. "Andre Norton." *Magic Carpet Con Program* [fanzine], May 7, 8, 9. Dalton, GA.

A brief biography and overview. Mentions the view that "Miss Norton has yet to receive the thundering acclamation to which she is so justly entitled." Thanks Andre Norton for "allowing us to honor her with this convention."

D127 Anon. "Norton, Andre 1912-." *Major Authors and Illustrators for Children and Young Adults: A Selection of Sketches From Something about the Author.* Volume 4: K-N. Eds. Laurie Collier and Joyce Nakamura. Detroit: Gale Research.

Bibliography through 1992. Contains a paragraph about the 1982 movie *Beastmaster.* Nice complete biography taken from interviews by Crispin (D118) and Walker (D34).

D128 Clute, John. "Norton, Andre." *The Encyclopedia of Science Fiction.* Eds. John Clute and Peter Nicholls, New York: St. Martin's Press. pp. 877-878.

This is a good overview of Andre Norton's writings through 1991. The first part of the entry is an analysis which mentions the early books outside of the science-fiction genre. The entry then describes her career as being divided into two periods, the twenty years from 1950 through 1970 and the twenty years after 1970. The first period has a concentration on science-fiction novels, mostly in one galactic super-series. After 1970, and the success of the *Witch World* science-fantasy sequence, she produced mostly fantasy. The entry mentions the important themes of "rite de passage" and Sense of Wonder. Says that Andre

Norton has a style where science and technology are treated "perfunctorily (if at all)." The summation paragraph states that her style has matured, her plots have tended to darken, there is a high degree of narrative control. This review is followed by a bibliography with those titles not previously cited in the entry in order of publication date, through 1991.

D129 Schlobin, Roger C. "The Formulaic and Rites of Transformation in Andre Norton's 'Magic' Series." *Science Fiction and the Young Reader.* Ed. C. W. Sullivan III, Westport, CT: Greenwood Press, pp. 37-45.

Accepts that the Magic Books, and others of Andre Norton's juveniles, follow the formula of young person(s) displaced and unhappy, who discover a fantasy world, perform some heroic task in that world, and return to their own world transformed into better people for having met those challenges. The basic formula for this transformation is surrounded by characterization, adventures, and additional messages of acceptance and recognition which appeal to young people.

1994

D130 Anon. "200 Most Important People: Andre Norton." *Starlog Issue #200.* March. p. 13.

Very brief biography with a nice black and white photo.

D131 Schlobin, Roger C. "Andre Norton, The Author Becomes Her Fiction and Creates Life." *Science Fiction & Fantasy Book Review Annual 1991.* Eds. Robert A. Collins and Robert Latham. Westport, CT; London: Greenwood, pp. 172-177.

Uses a discussion of Andre Norton's life and writings to expand on the thesis that a feeling of alienation in her own life led to the creating of fictional characters that move beyond their own alienation. The themes created by Andre Norton express her utopian wish for harmony and mutual support. These fictional themes are, in turn, reflected in Andre Norton's support and generosity toward other writers. This is an upbeat theme in contrast to Rick Brooks' "Andre Norton: Loss of Faith" (D29).

PART E
PHANTOMS AND PSEUDONYMS

As Roger Schlobin stated in his Introduction, Andre Norton is not a pen name but a legal name change. Many libraries that I have visited, as well as the Library of Congress, seem to foster this error even though Andre has "never published using her [birth] name." [Personal conversation May 1993—I. R. H.]

I've found several bibliographies that continue this error, and manage to compound it by including the writings of other people. The following are NOT Andre Norton;

- Alden H. Norton has published several science fiction anthologies. Some of his books have A. Norton on the cover.
- Alice Norton is a librarian from Ridgefield, CT, who has several library publications on Library Publicity.
- Mary Alice Norton is the author of the Borrower Books.

Andre Norton has used only three pseudonyms to my knowledge.

- The name Andrew North was used for the fiction written during the years that Andre was editing several anthologies for World Publishing. The name was used to avoid confusion.
- Allen Weston was used only once, for the book *Murders for Sale* (A20) which was written with Grace Allen Hogarth. This book was reprinted as *Sneeze on Sunday* (A194) without the pseudonym.
- In the early 1980's Andre prepared two books for publishing for Enid Cushing. One of these, *Maid-at-Arms* (A148), required little work and was published as by Enid Cushing. The second book, *Caroline*, acknowledges the joint authorship. [The manuscript of *Maid-at-Arms* and correspondence in Syracuse University Library.]

There are only a few phantoms accredited to Andre Norton. Most of these are either misspellings or ISBNs issued for an edition that was never published.

- *Murders for Sale* (A20) appears in many bibliographies as *Murder for Sale*.

- *Star Ka'ats and the Winged Warriors* (A149) was never published in paperback (or at least not as far as I can discover), though there is an ISBN for this book.

73

- Moskowitz & Elwood, *The Human Zero*, 1967, New York: Tower [paper]. Cover notes indicate that Andre Norton's "The Gifts of Asti" is inside. This is not true.

- The interview in *Locus* (D122), mentions *The Day of the Rat* as a proposed sequel to *The Mark of the Cat* (A198). Andre said (interview at the World Fantasy Convention, 1992) that "they [the publishers] didn't want it."

- *Were-Wrath* (A159) is incorrectly listed in some places as *Were-Wraith*.

APPENDIX I
GENRES

The genres of Andre Norton's works will always be a source of controversy. In many of them, there are clear mixtures of science fiction and fantasy. In these cases, the following classifications have been determined by the predominant content, occasionally in direct contrast to a narrative frame that appears to indicate another genre. Also, it is often not clear whether Ms. Norton's works are specifically adult or juvenile. Those titles with adult appeal have been listed as such, and only those that are clearly identifiable as children's books have been listed as juveniles. In making these classifications, I [Roger Schlobin] am strongly indebted to Helen-Jo Jakusz Hewitt's "Andre Norton Bibliography" (D44); her genre designations have served as a guide and a foil to my own determinations. The codes following each title refer to the main entries in the bibliography.

FANTASY

"Amber Out of Quayth," A87
Black Trillium, A184
"Changeling," A141
"The Chronicler: 'Once I was
 Duratan…'," A196
"The Chronicler: 'There are places
 in this ancient land…'," A210
"The Chronicler: 'There was a
 time…'," A189
The Crystal Gryphon, A89
"The Dowry of the Rag Picker's
 Daughter," A173
"Dragon Scale Silver," A91
Dread Companion, A79
"Dream Smith," A92
The Elvenbane, A190
Empire of the Eagle, A205
Exiles of the Stars, A86
Forerunner Foray, A99
"Garan of Tav," A94
"Garan of Yu-Lac," A75
The Gate of the Cat, A167
"The Gifts of Asti," A07
Golden Trillium, A206
Gryphon in Glory, A146

Gryphon's Eyrie, A156
The Hands of Lyr, A212
"Hob's Pot," A191
Horn Crown, A147
"How Many Miles to Babylon?"
 A174
Huon of the Horn…, A11
The Jargoon Pard, A106
"Legacy from Sorn Fen," A95
The Mark of the Cat, A198
Moon Called, A151
Moon of Three Rings, A62
"Nine Threads of Gold," A200
"Noble Warrior," A182
"Noble Warrior Meets with a
 Ghost," A213
"Of the Shaping of Ulm's Heir,"
 A169
"People of the Crater," A05
"Port of Dead Ships," A192
Quag Keep, A132
"Rider on a Mountain," A170
Rogue Reynard…, A06
"Sand Sister," A137
Serpent's Tooth, A171

ANTHOLOGIES

APPENDIX II
SERIES, SEQUELS, AND RELATED WORKS

The following groupings indicate the interrelationships among Andre Norton's fiction. In all cases, except the Magic Series, the works are listed in the order established by their internal chronology. The Magic Series is a group of juvenile novels focusing on the supernatural and unified only by their titles and their common use of a central symbol (see Introduction). For each category, sustained characters are noted, when appropriate, and the codes following each title refer to the main entries in the bibliography.

We are indebted to Helen-Jo Jakusz Hewitt's "Andre Norton Bibliography" (D44) for a number of the series arrangements and for some of the series titles (with the exception of the Solar Queen and Witch World series, Norton does not title her groups of fiction). Sandra Miesel's thorough examination of the Witch World Series in "A Chronological Chart of Andre Norton's Witch World Novels [and short stories] Indicating Time and Geographical Relationships" (D57) has been an invaluable aid in arranging those works. Serious students of the Witch World would do well to consult Miesel's chart for a more sophisticated classification than is given here. I am also indebted to Sasha & Ben Miller (D119) for their time line of the Witch World.

ASTRA (setting)
The Stars Are Ours! A22
Star Born, A32

BEAST MASTER
Hosteen Storm, protagonist
The Beast Master, A36
Lord of Thunder, A48

CIVIL WAR
Drew Rennie, protagonist
Ride Proud, Rebel! A44
Rebel Spurs, A49

JANUS (setting)
Naill Renfro, protagonist
Judgment on Janus, A50
Victory on Janus, A64

MAGIC
Steel Magic, A57
Octagon Magic, A66
Fur Magic, A71
Dragon Magic, A90
Lavender-Green Magic, A107
Red Hart Magic, A121

MOON MAGIC
Krip Vorlund and Maelen, protagonists
Moon of Three Rings, A62
Exiles of the Stars, A86
Flight in Yiktor, A165
Dare to Go A-Hunting, A185

SHANN LANTEE

common character and/or
 protagonist
Storm Over Warlock, A42
Ordeal in Otherwhere, A54
Forerunner Foray, A99

SOLAR QUEEN

Dane Thorson, protagonist
Sargasso of Space..., A24
Plague Ship..., A28
Voodoo Planet, A39
Postmarked the Stars, A76
Redline the Stars, A207

STAR KA'AT

Star Ka'at, A117
Star Ka'at World, A133
Star Ka'ats and the Plant People,
 A140
Star Ka'ats and the Winged Warriors,
 A149

SWORDS

Lorens van Norreys, protagonist
 and/or common character
The Sword is Drawn, A04
Sword in Sheath, A09
At Swords' Points, A17

TIME TRAVEL/
ALTERNATE WORLDS

Blake Walker, protagonist
The Crossroads of Time, A27
Quest Crosstime, A56

TIME WAR

Ross Murdock, Travis Fox, and
 Gordon Ashe, protagonists
 and/or common characters
The Time Traders, A35
Galactic Derelict, A37
The Defiant Agents, A46
Key Out of Time, A51
Firehand, A211

WITCH WORLD

Horn Crown, A147
"One Spell Wizard," A96
"Dream Smith," A92
"Of the Shaping of Ulm's Heir,"
 A169
Witch World, A52
Web of the Witch World, A55
The Crystal Gryphon, A89
"Dragon Scale Silver," A91
"Sword of Unbelief," A128
"Toads of Grimmerdale," A104
"Changeling," A141
Year of the Unicorn, A60
"Amber Out of Quayth," A87
"Legacy from Sorn Fen," A95
Three Against the Witch World, A58
"Sword of Ice," A125
"Sword of Lost Battles," A126
Gryphon in Glory, A146
"Sword of Shadow," A127
The Gate of the Cat, A167
Warlock of the Witch World, A68
Ware Hawk, A154
The Jargoon Pard, A106
Sorceress of the Witch World, A72
"Spider Silk," A122
Zarsthor's Bane, A135
"Sand Sister," A137
"Falcon Blood," A136
Gryphon's Eyrie, A156
Songsmith, A201
"Port of Dead Ships," A192
"The Chronicler: 'There was a
 time...'," A189
"The Chronicler: 'Once I was
 Duratan...'," A196
"The Chronicler: 'There are places
 in this ancient land...'," A210

FORERUNNER

Simsa and Thom Chan-li,
 protagonists
Forerunner, A145
Forerunner: The Second Venture,
 A160

TRILLIUM
Black Trillium, A184
Golden Trillium, A206
[*Blood Trillium* by Julian May]

ZERO STONE
Murdoc Jern and Eet,
protagonists
The Zero Stone, A73
Uncharted Stars, A78

ZACATHANS as protagonists
Brother to Shadows, A204
Dare to Go A-Hunting, A185
 [Zacanthan]
Star Rangers, A16
Uncharted Stars, A78

PRIMARY INDEX

The following is an alphabetical index by title to the works of Andre Norton. Citations are to sections and items.

SECONDARY INDEX

The following is an alphabetical index by author to works about Andre Norton. Citations are to sections and items.

Crawford, Wm. L. "Introduction to 'Garan of Yu-lac'," D25

Crispin, A. C. "Queen of the Witch World: Andre Norton," D118

Culpen, Norman. "Norton, Andre," D63

Currey, L. W. "Norton, Andre," D71

D'Ammassa, Don. "Andre Norton: Short Story Writer," D99

Dickholtz, Daniel. "100 Most Important People:...," D100

Donaldy, Ernestine. "She Lives Ahead—In 1980 Plus," D09

Eaton, Anne T. "For Younger Readers," D02

Elgin, Suzette Haden. Review of *Seven Spells to Sunday*, D72

Ethridge, James M., and Barbara Kopala, eds. "Norton, Alice Mary," D22

F. A. C. "*Ralestone Luck.*," D01

Fisher, Margery. "Special Review: *Catseye*," D15

Fisher, Margery. "Special Review: *Plague Ship*," D30

Fisher, Margery. "Writers for Children: 8. Andre Norton," D23

Fraser, Brian M. "Putting the Past Into the Future," D83

Fuller, Michael, ed. "Andre Norton," D16

Garcia, Nancy, and Mary Frances Zambreno. "Andre Norton," D114

Hayes, Sarah. "Far Flung Worlds," D43

Hensley, Charlotta Cook. "Andre Norton's Science Fiction...," D84

Hewitt, Helen-Jo Jakusz. "Andre Norton Bibliography," D44

Hills, Greg. "A Review of *Ware Hawk*," D101

Holdom, Lynne. "A Look at Andre Norton's Work," D86

Houston, B. R. Chris. "SF Speakout: Andre Norton," D45

Hunt, Peter. "World Weary," D52

Kane, Russell W. "The Science Fiction Shelf," D17

Laskowski, George "Lan". *Lan's Lantern 16*, D102

Lichtenberg, Jacqueline. "Thank You Andre," D103

Linaweaver, Brad. "The *Squonk* Interview: Andre Norton," D64

Lofland, Robert D. "Andre Norton, A Contemporary Author of Books for Young People," D10

M. G. D. "Lorens Goes to War," D03

Mallardi, Bill, and Bill Bowers, eds. *The Double: Bill Symposium...*, D26

Manly, Seon, and Gogo Lewis. Introduction to "Through the Needle's Eye," D53

McGhan, Barry. "Andre Norton: Why Has She Been Neglected?" D27

Miesel, Sandra. "Bibliography of Andre Norton's Witch World," D58